Glyn Morgan at Eighty

Glyn Morgan
at Eighty

David Buckman

Sansom & Company

First published in 2006 by Sansom & Company Ltd.,
81g Pembroke Road, Bristol BS8 3EA

© David Buckman and Glyn Morgan

ISBN 1 904537 44 8

Publication of this book coincided with exhibitions of the artist's work at the
National Library of Wales, Aberystwyth (January 7 : February 25, 2006) and
Chappel Galleries, Essex (April 29 : May 21, 2006).

British Library Cataloguing-in-Publication Data
A catalogue record for this book is available from the British Library

Designed and typeset by Stephen Morris smc@freeuk.com
Printed in Malta by Gutenberg Press Ltd.

Contents

Glyn Morgan at Eighty

Foreword

THROUGHOUT THIS SURVEY OF SIXTY YEARS OF GLYN MORGAN'S ART we see striking examples of his gift for the accurate representation of whatever he observes. The precision of his studies of flowers shows how a distinguished career could have been devoted entirely to work in this mode. He has, however, chosen to concentrate above all not on what he sees directly but rather on representing the active presence, within the verifiable world of nature, of inward and immanent forces. A subject of this kind, in which his spirit is engaged still more fully, is not susceptible of a wholly objective approach.

His art does not arrest the viewer through an idiom of his own invention. What makes it so distinctive is the rich interconnectedness of the elements of his vision and the satisfying completeness with which these are deployed afresh in each work to make a statement that could only be his.

His impulses declare deep affinity with those of several painters who worked before him in both Wales and England, and who he follows in being drawn, too, towards the Mediterranean world. These include Samuel Palmer and Graham Sutherland, but also two key teachers of his, Cedric Morris and Ceri Richards (both of whom were Welsh-born). In Morgan's work, as in that of all of these except Morris, there is a mystical dimension. For him, this is strongly connected to the differing sensibilities of Paul Nash and Georges Braque. In Nash, flowers respond to unearthly forces and there is a sense of movement upwards, as well as of direct contact between forms close at hand and distant numinous sites. Flight, which for Nash was a vital metaphor for a spiritual journey, is also a crucial theme in the late paintings of Braque, in which (as in Nash's) a central concern is the evocation of space. All these characteristics resonate in Morgan's work. His recent *Landscape Motif* series seems close not only to Nash (in its juxtaposition of near with far, low with high) and to Palmer and Sutherland (in its intimate, 'folded' quality) but also to Braque's *Studio* pictures. These new landscape images combine a rich density with the careful articulation of layers in spatial depth. The formal structure of each work builds up in a very satisfying way; in parallel, viewers can feel their way through a scene. There is a certain increase in freedom, often thought of as symptomatic of the work of older artists.

Morgan's landscapes are animated by light, whether glimmering or pervasively radiant. The openness of Welsh landscape to the elements feeds into them, but their light seems as much supernatural as naturalistic. This quality, too, has a Welsh dimension, for it relates to Morgan's interest in myth and legend, preoccupations that have deep roots in Wales. A recent series of paintings gives striking form to the tale, from the *Mabinogion*, of Blodeuwedd who, made from flowers by the resident magician as a bride for a Welsh nobleman, proved unfaithful and was punished by being turned into an owl.

Many of Morgan's paintings concern particular myths of classical origin (an interest

reinforced by his visits to Italy and the Eastern Mediterranean). In these the details, though of great visual beauty, are again often disturbing. Chased by Apollo, his head emitting rays of golden light, Daphne is changed into a tree. Orpheus is decapitated. Dionysos turns pirates into dolphins and Leto turns the Lycians into frogs. Morgan's interest in myth attests his twin delights in narrative and (like Cedric Morris) in plants, animals and birds, yet its central concern is with processes of transformation. This key theme inspires his memorable visualisations of moments of change from one state to another, his evocation of the quality of magic and his often improbable juxtapositions of form. While giving his motifs insistent presence, it also permits him partially to camouflage them, thus increasing awareness of a painting's abstract properties, of the quality of his manipulation of paint and of his natural grace in the making of marks. He loves the sense of transition between elements – earth and water, earth and air, material reality and the world of the spirit and, of course, a picture's subject and paint itself. Braque's *Studio* pictures, at once indoors and out, earthy and aerial (and centred on the transformative power of the painter's craft), again provide a point of reference. They demonstrate, as do Morgan's paintings, the value of a degree of ambiguity in enriching a picture's content.

Each of Morgan's pictures creates an atmosphere into which the viewer can enter very directly. Whether the subject be an encounter from myth or a stretch of land and sky, dream and imagination are so aroused that while looking we believe in the existence of what we are shown. The works induce a state that is attentive to detail but essentially one of feeling, an effect akin to poetry or music, in each of which mood is conjured out of the raw materials of words or sounds. It is therefore not surprising that music is of great importance to Morgan (as it also was to Braque and Richards). Not only does he seek parallels to the vision of great composers, especially Mahler, but in the relations between pictorial elements he finds increasingly that painting, as process and for the viewer, is itself akin to music.

Also running through Morgan's work is a vein of humour, even a delight in mischief (not least among the Gods). It is not difficult to relate this to the contrasting personalities of both his teachers, across the decades, at Benton End, Hadleigh (in which town he now lives). Cedric Morris has been mentioned, but also important was Morris's partner, Arthur Lett-Haines, whose art drew above all on organic motifs from nature, which he subjected to humorous and at times disturbing transformation. Nevertheless, Morgan's humour is again clearly his own. It is understated, observant and affectionate.

At home in two regions of Britain and participating in a wider European heritage, Morgan makes a distinctive contribution to a tradition of imaginative painting in which he works with freshness and ease.

RICHARD MORPHET, KEEPER OF THE MODERN COLLECTION, TATE GALLERY 1986-98

Introduction

THROUGH A LIFETIME DEDICATED TO PAINTING, GLYN MORGAN has joined that important body of Welsh artists who have transformed the role of the visual arts in the principality in the twentieth century. With his early teacher Ceri Richards, his mentor of many years Cedric Morris, and other singular painters such as Evan Charlton, John Elwyn, Alfred Janes, Augustus John, Peter Prendergast, Will Roberts and Kyffin Williams, Morgan has helped dispel the myth that the Welsh are not a visual nation. British art of the twentieth century would be much less richly diverse without their contribution.

Like most of those named, Morgan chose to live mostly in England, ensuring that what he produced would enter the artistic mainstream. Like all these Welsh artists, he is a painter of marked individuality, whose work in a mixed show is instantaneously recognisable. Morgan's Welsh background has informed his art in a number of ways. He is a confessed romantic, a visionary, producing work steeped in dream, imagination and legend. He aspires not just to surface realism, but an inner reality, probing the mystery in the earth and all growing things. Combine this quest with a rich palette and you get powerful and evocative pictures whose impact is not always immediate, but are over time long-lasting in the memory.

'The primary purpose of art is to uplift the human spirit,' Glyn Morgan has written. It is a high and now rather unfashionable aim, but the life-enhancing canvases illustrated in this book, produced over more than 60 years dedicated to his craft, show that he has done more than most to achieve it.

A note about media
Unless stated otherwise, all works accompanying the essay are oil on canvas.
All measurements are in inches, height before width.

Origins

GLYN MORGAN WAS BORN IN 1926 IN PONTYPRIDD, Glamorgan, at the junction of the Taff and Rhondda valleys. It was not a mining town, but trains moving coal from mines in those valleys travelled through Pontypridd to Cardiff. 'A fully loaded coal train went past the front of our house roughly every five minutes,' Morgan recalls. 'My father's father was a miner, but my father, Henry Ivor Morgan, always known as Ivor, worked for the Great Western Railway. I think he did marvellously well. Having left school at 11, he worked his way up to be chief clerk in the main booking office in Cardiff. My mother, Gladys Caroline Baker, was English, born and brought up in London where I think they met, after my father had been widowed and left with a son, Trevor. She had lost her fiancé in the First World War. I suppose that up to a point it was a marriage of convenience, without a great love affair involved.'

After Ivor brought his new wife back to Pontypridd, he appointed a builder and built a couple of bungalows. One he sold, the Morgans living next door in the other. Another of Ivor's enterprises was the ownership with his brother of two newsagents in the town. When Glyn was young that uncle died, so that the shops became Ivor's sole charge. Gladys looked after one of the shops while Ivor went off to his job in Cardiff. 'She didn't like it very much, for he didn't pay her anything. My father was by now doing quite well, on a small scale, for someone who had left school so young. He was an intelligent man, not particularly educated. With a proper education, I think he would have ended up as the managing director of something or other.'

Also living with Ivor, Gladys and Glyn was his 14 years older half-brother, Trevor, by Ivor's first marriage. Trevor studied at Cardiff University, where he played rugby – 'they tried to get me interested in it, too, but failed miserably,' Morgan laughingly recalls – then at Oxford, before going on to teach. He eventually became director of education for Monmouthshire, dying a few years ago. 'My parents were very pleased when he got into Oxford. It had been a Welsh tradition that education was important, certainly it was then.' The two boys always got on well, and while he was at Oxford, in the mid-1930s, Trevor regularly sent Glyn drawing books, as his artistic aptitude had already become apparent.

'I would soon fill up the books with drawings of cars, planes, trains and numerous pictures of the liner *Queen Mary*, then still building and known as no. 534. As a child I also constructed altars of gravel with flower and leaf offerings.'

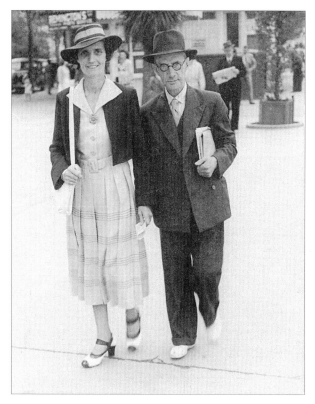

The artist's parents

Although this was an area with a strong religious background, Ivor Morgan and his wife were not devout chapel-goers, although Glyn's mother, described by Glyn as 'having had a proper education, but not particularly intelligent,' did toy with Spiritualism for a time. On reflection, Morgan thinks that the altars he then made were in a way precursors of his later Offerings and Table of Minos pictures. 'I suspect, too, that they may have had something to do with the not particularly happy relationship that my parents had. Children tend to feel guilty about that sort of thing – the offering as a sort of expiation.'

The 11-plus was not invented then, so it was a selection process that enabled Glyn as a bright boy to enter Pontypridd Grammar School. 'It was a very good school. My first art teacher was a ferocious Scot, who had a rope with a knot at the end with which he would whack boys who misbehaved. His art teaching consisted of funny sorts of watercolours that looked rather like paper sculpture, which you had to copy, also patterns and how to put a wash on. Oddly enough, I loved it. It was learning a technique, which I enjoyed. When he left for the Army a nice, friendly man called J R Llewellyn replaced him who was more modern in outlook. I liked him, too, because he gave me much more freedom and I was getting to an age when I could make use of it. Then he went into the Army and his wife Lorna took over. In my later years at the school I managed to give up a lot of subjects for extra art.'

Cardiff College of Art

AFTER TAKING HIS EXAMINATIONS AT 16, MORGAN WAS ACCEPTED AS A STUDENT by Cardiff College of Art, remaining there from 1942 to 1944. 'I took some drawing books, full of aeroplanes and cars and things like that, and they told me gently that I would have to start drawing people. My father had no interest in art and didn't understand it, but wanted to do right by his children. Once he found that if you studied it you could become a teacher, that was all right. My mother thought that everything I did was wonderful because I was her child.'

Morgan was fortunate in going to Cardiff, where Evan Charlton was a good principal, a fine painter whose pictures have a Surrealist edge. Morgan recalls Charlton as stern but pleasant, who would 'stand no nonsense.' He would shortly leave to become an His Majesty's Inspector for art in Wales. Cardiff insisted that you learn your craft as an artist, skills that Morgan regrets are now rarely taught. 'You did two years' drawing – life drawing, drawing from the cast – as well as architecture and anatomy, and after that you chose either painting or illustration. It would have been logical to do painting, but I looked at what they were doing and wasn't impressed, as the students only seemed to use black, khaki and dark green.

'By that time Ceri Richards was teaching what they called illustration, although it was all sorts of things. He was a marvellous teacher. I remember Richards mainly for the life classes. His method was to focus on one section of the model – say, the knee joint – and do an incredibly delicate and penetrating diagram showing the hardness of the bone, the softness of the flesh and stresses pulling the skin. The power of his concentration was palpable.' Knowledge of what was happening in the wider artistic world at that time was commonly very limited in out-of-London art schools, but Richards, Royal College of Art-trained, who had worked as illustrator for the London Press Association and who was well aware of developments in Paris, ensured that Cardiff students' horizons were extended. 'He put up and would discuss reproductions that he'd framed around the room he worked in. I remember particularly Picasso's illustration for the cover of *Minotaur*. We used to visit Cardiff Museum, where they had works by artists such as Augustus John and where I think I saw my first Cedric Morris.'

Morgan's drawing *Nude (Sarah)*, 1954, shows his debt to Richards. He says that it 'was named after Gulley Jimson's wife in Joyce Cary's novel *The Horse's Mouth*,' which was published that year.

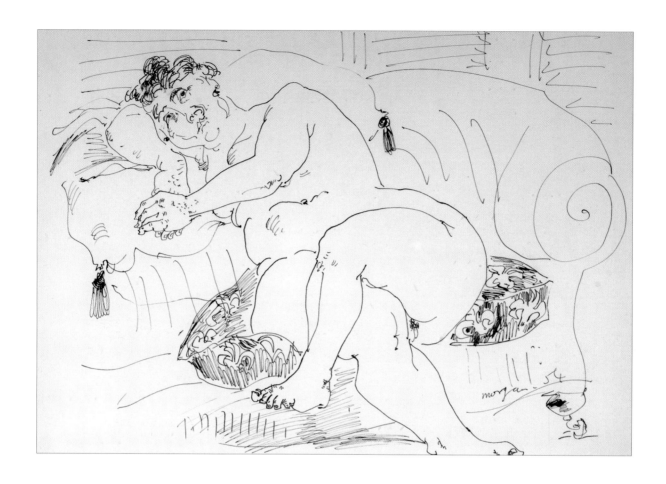

Nude (Sarah)
1954
pen 14 x 20

Morgan was also making exciting discoveries with his friend and fellow-student Glyn Griffiths. He was a fine realist painter and draughtsman who eventually taught at Birmingham College of Art and elsewhere, by which time Morgan had lost touch with him. It was only after Griffiths's death, in 1999, that his second wife contacted Morgan, and he was able to contribute to the 2002 Griffiths retrospective at The Royal Society of Birmingham Artists Gallery and at Newport Museum and Art Gallery. Morgan contrasted his own student shyness with Griffiths, 'a glamorous personality, strikingly handsome with blond hair and piercing blue eyes, with an air of confidence that was invigorating…We entered a whole new world together, discovered Picasso, Stravinsky, Dylan Thomas, D H Lawrence and many others, and discussed them on numerous drawing expeditions. We also discovered the ventilation tunnels that honeycombed the college, and explored them on hands and knees amid clouds of dust, peering through grilles into forbidden rooms. On fire watching nights we roamed the roofs and planned to descend into the principal's study through the skylight. Luckily, this

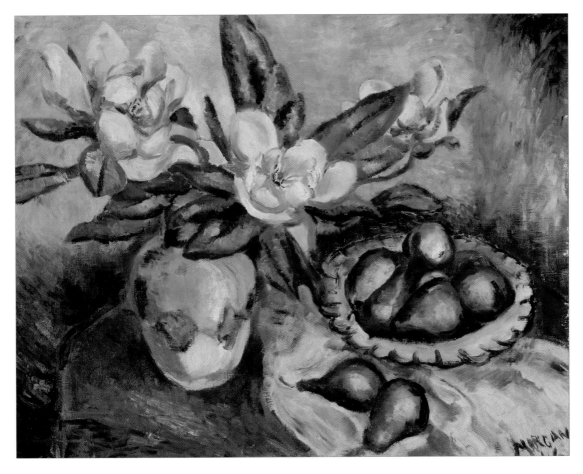

never happened.'

Magnolias
1946
28 x 36

While studying at Cardiff Morgan encountered another key person in his life, Esther Grainger. After herself studying at Cardiff, she began teaching crafts to the wives of unemployed miners, later organising painting classes and exhibitions at the Pontypridd Settlement. There she met the artist Cedric Morris, who also taught her. Morris in the pre- and post-war periods was a dynamic force in developing awareness of the visual arts in the principality. It was not surprising that in 1943 Glyn decided to put a couple of pictures into a show at the Pontypridd Settlement where Morris was doing the selecting. It was a life-transforming meeting for the seventeen-year-old Morgan. 'He thought that mine were promising and said: "Why not come to my painting school in Suffolk?"'

In the summer of 1944, Glyn booked a week at Benton End, formally known as The East Anglian School of Painting and Drawing. A wartime journey from South Wales to Suffolk was not easy. 'I think it took me all day on the train. I remember I used a taxi from Ipswich to Benton End, where Cedric came out to meet me and

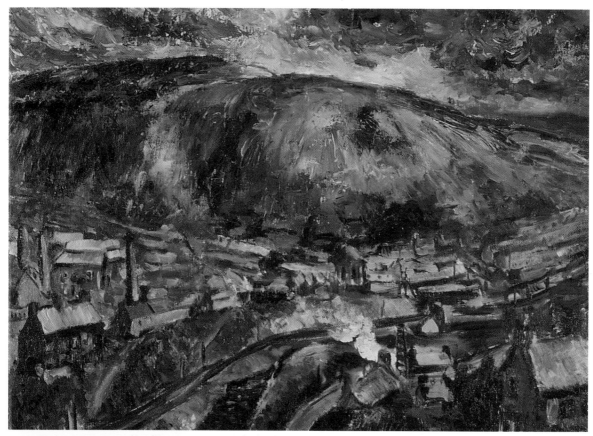

Porth, Rhondda 1946 oil 30 × 40

Portrait of the Artist's Mother

was very welcoming. I knew then that everything was going to be fine.'

During these early years of acquaintance with Benton End and after his Cardiff studies were finished, Morgan completed works that indicate how he was still seeking to find a personal style and subject matter. They included two finished in 1946: the still life *Magnolias* and the view of *Porth, Rhondda*, which is in the collection of the National Museum of Wales in Cardiff; and *Portrait of the Artist's Mother*; and a *Crucifixion*, painted in 1947. In the first there is a hint of the later visionary quality that would dominate his mature works, but realism remains dominant. Of *Porth, Rhondda*, Morgan was to remark wryly in the catalogue of his 1981 Minories retrospective in Colchester that it was 'in what one might call a Romantic-Wagnerian style.'

Camberwell Interlude

MORGAN LEFT CARDIFF COLLEGE IN 1944 and it was 1947 before he was able to resume his studies. This time his choice was Camberwell School of Arts and Crafts, in southeast London, then a magnet for aspiring artists. It was entering arguably its most influential period under the principalship of William Johnstone, a Scot who had studied in Paris. In his 1980 autobiography *Points in Time* Johnstone recalls how after the war 'nearly three thousand students flocked to Camberwell and extra buses were put on from Camberwell Green…We were practically out to the door, so that everybody crowded in to get an easel otherwise they had to paint long-distance or paint the back of somebody's head instead of the model.' Many students were prepared to put up with these conditions in order to be taught by luminaries including William Coldstream, Victor Pasmore and Claude Rogers.

When Geoff Hassell compiled his 1995 book on the period, *Camberwell School of Arts & Crafts*, Morgan recalls that 'I was the only contributor who said that he hated the school. He nobly printed it. I wrote: "I went there attracted by the illustrious names, but the place was so overcrowded (I counted seventy people in one life class) that it was diffficult for it to function properly." Though painting was what I always wanted to do, I soon switched to illustration where I was happier and received some worthwhile teaching. I particularly remember John Minton, a charming man, and a most energetic and inspiring teacher.'

Morgan adds: 'Minton was friendly, really put his back into it and earned his money. Hardly any of the others did. I found Coldstream extremely boring, dry as dust and academic, and I didn't get a lot from him. Ruskin Spear was also there, but I didn't see much of him. Victor Pasmore I had great hopes of, but his work was about to change, I think – just in time for the Festival of Britain. He used to do the register and then go home. I never saw him doing any teaching. We didn't see much of Johnstone. I remember he gave us a talk once, the gist of which was that somebody was good because he was modern. That didn't impress me very much, and I got disillusioned. I soon left and regained my sanity by spending several months at Benton End. My strongest memory of Camberwell is the smell of cabbage drenched in bicarbonate of soda.'

Benton End

NOTHING COULD HAVE BEEN A GREATER CONTRAST TO DRAB, SUBURBAN CAMBERWELL than the intimate, civilised Eden of Benton End. Cedric Morris had opened The East Anglian School of Painting and Drawing early in 1937 with his lifelong companion and fellow-artist Arthur Lett-Haines. 'Everybody called him Lett, or Father,' recalls Morgan. 'Haines was never used, except when Cedric wanted to be prickly, when he called him "Mister Haines".' Cedric was the East Anglian School's principal, Lett handling the organisation at the unique institution that operated for almost 40 years, numbering among its students Joanna Carrington, Lucian Freud, Maggi Hambling and Bernard Reynolds and his wife Gwynneth. It was she who helped gather the memories, those of Morgan included, of this 'mecca for artists, gardeners, plant collectors and creative people of many and varied talents' in the delightful 2002 volume *Benton End Remembered*.

'Cedric and Lett had left London to set up the school,' Morgan says. 'Lett wouldn't have approved, because he liked cities. Cedric didn't, he had got fed up with the gallery system, so he broke his contract with the dealer Tooth's and he and Lett settled in Higham, between Hadleigh and the A12. To live in they bought The Pound, a wonderful house deep in a little valley. Cedric started a garden there and they had all sorts of pets – a macaw and peacocks, I think – while renting a studio in Dedham, where the students worked. When it was burned down they had to find somewhere for the school, which was Benton End. For the first time the students were in the same building as Cedric and Lett, which was much better. I believe Cedric and Lett each had a bit of private money, which Cedric never talked about, because he didn't approve of it! – but living and property were cheap then.

'I think students, who were there from April to October, were found by advertisements in *The Studio* and by word of mouth. I suppose you could get eight to 10 students in the house if you shared rooms, and then a few others lodged in the town. You didn't pay very much, considering that you had two enormous meals with wine and breakfast and tea. Lett did the cooking and Cedric the garden. The food was wonderful and they couldn't have made much of a profit. Occasionally you would get 14 or 15 sitting down to dinner, and there were guests from time to time.

'Cedric and Lett had a wide circle of friends, many met while they were in Paris. Gwilym Lloyd George, a Member of Parliament and son of the former

Prime Minister, came once, a nice chap, and I was left to entertain him. Angus Wilson, the writer, was another visitor. Conversation around the table would be general or in small groups. Lett would wander in from the kitchen and interrupt, usually irritating Cedric, then he would wander out again. He never sat down to a meal with the rest of us. I don't know when he had his food and I don't think he did have much to eat. The evening meal would go on until 10 o'clock. People would drift off to bed, some of us staying to talk to Cedric.

'He would be in the garden by six or seven in the morning and Lett would get up about midday, start the cooking, do the lunch and go back to bed again. I think Cedric was a self-taught plantsman. The only time I saw him painting was when he was doing my portrait. He had a studio away from the students and didn't do much when they were there. Lett didn't do any painting at that time, not until Millie Hayes arrived some years later as housekeeper. Most of the students were middle-aged schoolmistresses, with a sprinkling of psychoanalysts and a few students like me, but not many. Some were quite good, some very amateurish and some hopeless, but all were keen. It was a holiday for them, of course, and for me, as well.'

There is a surviving Benton End prospectus from the time of Morgan's first visits, cited in Richard Morphet's fine catalogue which accompanied the 1984 Cedric Morris exhibition at the Tate Gallery. That prospectus, while pointing out the need to learn technique and such essentials as the chemistry of paint and the stretching and preparing of canvases, emphasises that the student will be encouraged by more experienced artists in an atmosphere of freedom 'in a common endeavour to produce sincere painting.' Morgan recalls: 'Cedric, who was self-taught, didn't have an academic approach, didn't draw in an academic way and would never ever touch your picture. He talked about colour and balance and composition and things like that. He once said to me: "You have a disgraceful sense of colour, therefore you might be an artist." I think he meant that I wasn't going in for conventional colour, whatever that is. Not knowing anything about it, I didn't have a set of rules to apply, and he didn't believe in rules, anyway.

'On one occasion we both tried to do a still life with the most horrible colours imaginable, and make it work. The results, certainly mine, were not particularly attractive, but it was an interesting exercise.

'The aim of Benton End was to encourage people to develop what was natural to them, not an art school approach, rather the atelier system. Some students worked in the studio, a big room on the first floor which was very unsuitable as

the sun followed you round the building during the day. Others would work in the garden or would go out into the countryside. Cedric would come in from the garden some time during the morning and have a look at what you were doing, having seen the work being done in the garden, and then he would come in again after tea. If you wanted to talk you could fetch him or take your work out to him. It was all on an individual basis.'

After his first visit, Morgan returned to Benton End whenever he could for 38 years. It must have been like a second home? 'Oh, yes. It was much more enjoyable than my first home, for a start. It was just like another world, with the walled garden and the house, which I hardly ever left while staying there. I fell in love with the place, Cedric and Lett. I was always a highly emotional romantic, and when I fell for something it was 100 per cent. It was just a lovely place to be.'

Cardiff Again and Paris

AFTER CAMBERWELL AND WAR-TIME AGRICULTURAL WORK in various parts of the country, Morgan returned to Cardiff College of Art in 1948 to gain his art teaching qualification, but did not stay to complete the course. He was still in his early twenties, restless years when he was trying to determine what direction his life and work would take.

One diversion was a painting trip to Brittany, proposed by students at Benton End. 'The idea sounded attractive, and in the end three of us went: myself, Denise Broadley and a local painter, a schoolboy who came in from time to time. We went to St Malo on the boat, but the harbour was full of wrecks and we had to go in by motor boat. All the bridges were destroyed and it took us a whole day to get where we were going, on trains and crowded buses. The French were still very much recovering from the war. We stayed for three weeks in a big Norman nunnery at Tréguier, where they had a block set aside for visitors. The nuns were jolly

Harbour at Paimpol, Brittany 1948 24 x 30

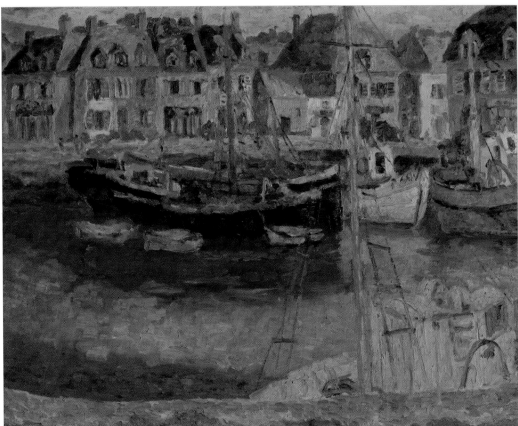

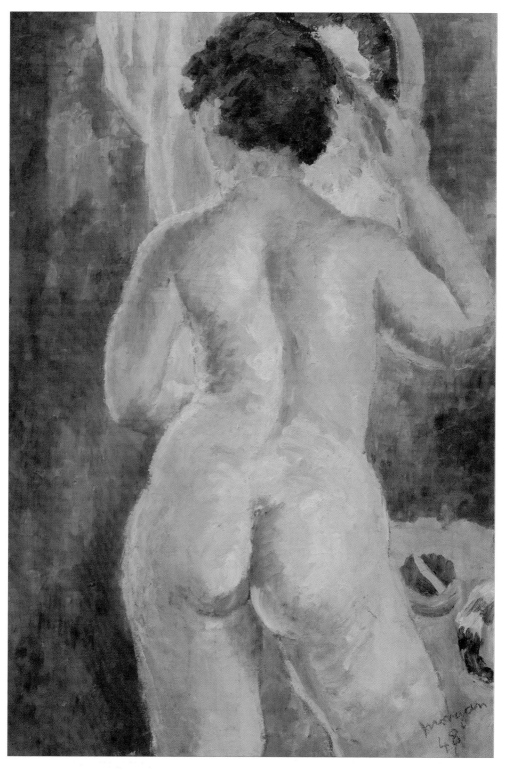

Nude (Hetty) 1948 36 x 24

and friendly, we enjoyed it very much and I think it was that that helped persuade Denise to become a nun. I did a few pictures, *Harbour at Paimpol, Brittany*, 1948, among them.

'It took me some time to establish my own style. I think this is because I have got a natural facility, drawing all those aeroplanes and cars all in perfect perspective, which I never seem to have had trouble with. At Benton End I found Max Doerner's book *The Materials of the Artist and their use in Painting*, translated from the German. I don't think Cedric had ever read through it, if at all. I used to dip into it and got fascinated with all the techniques, but it was like wading through wet cement. I tried Cedric's technique of dabbing, but not much, because he was self-taught and I had had an academic training and it wouldn't have fitted very well. The influence I had from him was mainly colour. The big lesson is that colour in a painting exists in its own right and is not necessarily representing the colour of certain objects.

'Around this period I tried a sort of Bonnard technique and Van Eyck, for which I did an underpainting in gouache and then glazed the pictures in oils. I painted some quite nice portraits in that way. Then eventually I settled down on what I am doing now.' *Nude (Hetty)*, 1948, and *Boy Dressing*, 1949, are good examples of the Bonnard style. 'Hetty was a wonderful model, compact and solid, who would pose for anybody. She was a student at Camberwell and after we finished there she came with me to Benton End. Hetty had an extraordinary life,

Boy Dressing
1949
28 x 15

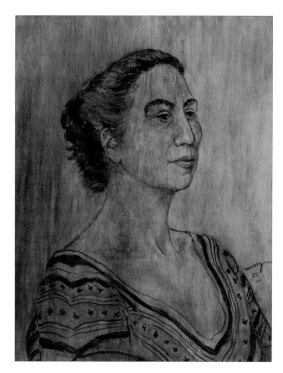

Mrs Tana Sayers 1955 oil on board 23 x 18
Priestess 1956 oil on board 25 x 19¹/₂

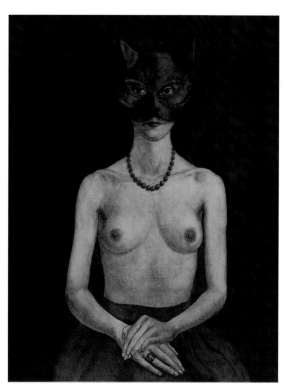

turning up with a trail of druggies at Benton End. Eventually she disappeared and it was when I was reading a book on the life of the writer Gerald Brenan, who lived in Spain, that – lo and behold, looking through the illustrations, there was Hetty! She had descended on him, then went off to Tibet and I haven't heard of her since.'

The need to earn a living prompted Morgan to start teaching in 1949 which he did for some years beginning at Ruabon Grammar School in North Wales and which included evening classes at High Wycombe School of Art and directing summer courses at Flatford Mill Field Centre, Nettlecombe Court, Somerset and the Aegina Arts Centre, in Greece. Among several talented pupils he taught was Ronnie Wood whom Morgan remembers as 'a nice quiet boy,' later famous as a member of the Rolling Stones. It was through teaching that Morgan met his future wife Jean, whom he was to marry in 1958.

Portrait of Jean dates from 1955, about the time of his *Self-Portrait* and *Mrs Tana Sayers*. 'Mrs Sayers was an American, staying at Benton End. The portrait of her was done with drawing, then gouache glazed over in oil. Although I have painted some good portraits and had an idea of doing it for a living at one time, I don't have a natural gift for likeness. It's always hard work.' The Sayers portrait was completed just before the haunting, enigmatic *Priestess*, of 1956. 'The subject was a friend who belonged to a coven, or said she did, dabbling in witchcraft and saying she levitated, which I did not believe. I put the cat mask on because I made a mess of the face. A doctor who saw the portrait said that no one as thin as that could survive, but she did.'

Realistic works continued through the 1950s, alongside these, such as *Berw Pool, Pontypridd*, 1950;

The Chain Works, Pontypridd, of 1955; *Cedric Morris in his Garden,* completed about two years later, a more elegiac work reflecting the garden and its maker; and *Benton End Garden,* 1960. 'The chain works picture, which I think is rather Picasso-ish, as well as the works and the tips includes the canal and St Catherine's church. It is historically interesting because the works and the tips are not there any more. The Pontypridd works made anchor chains for most of the British fleet for many years.'

Morgan would go on teaching until 'I got arthritic and deaf, so got out early. I always considered myself a painter who happened to be teaching. I didn't like teaching, but tried to do it as well as I could.'

During the early teaching years, Morgan was beginning to be noticed as an exhibiting artist, with the numerous group appearances and many solo shows that were to be a characteristic of his career. After contributing to an exhibition entitled Welsh Painting at the St George's Gallery in 1947, he was in Contemporary Welsh Painting at Heal's Mansard Gallery 1948. 'I have seldom seen so much promise in so young an artist,' Pierre Jeannerat, the perceptive art critic of the *Daily Mail* commented after seeing Morgan's landscape of Pontypridd in the London store exhibition. The *Western Mail* picked up the story, running a photograph of Morgan in front of his picture, noting that Jeannerat had scribbled on his catalogue: 'Good stuff and no kow-towing to fashionable styles.'

Even so, Morgan was to suffer the humiliation familiar to young painters trying to gain entry to the few big London dealers at that time. He was painting hard at weekends and as school holidays permitted. 'I remember taking a picture into the Leicester Galleries and they stood around sneering quietly

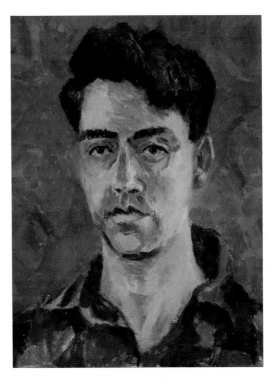

Self-Portrait c1954 oil on board 21 x 17

Portrait of Jean 1955 oil on board 20 x 16

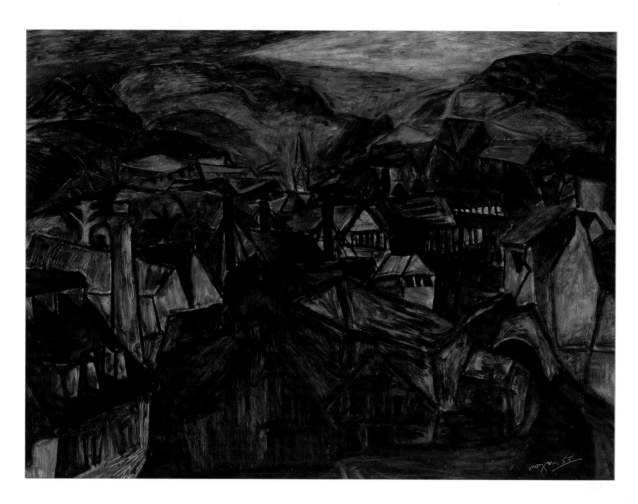

The Chain Works,
Pontypridd 1955
oil on board
29 x 39

while I struggled to unwrap it. I finally got it out, they sneered a bit more and said, "Thank you for coming in", and that was that. I believe I eventually had a picture in one of their Artists of Fame and Promise shows. Of course, it was naïve to just go into a gallery and expect them to be interested.

'I used to find people quite deferential when I went into Roland, Browse and Delbanco, then I discovered in the end that they had mistaken me for a quite well-known painter. Once they found out who I really was, they changed. At that time I did not establish any lasting relationship with a London gallery. There were so few of them and they were all very grand.'

Paris had by now become an important element in Morgan's life. In 1951 he spent several months there. 'Again rather naïvely I thought that this would help me to get a job in an art school. I could manage a conversation in French that was not too complicated, so I persuaded my father to pay and off I went. When I arrived I immediately got flu and spent three weeks in bed eating nothing but

oranges. Once I'd recovered I really enjoyed myself.

'I lived in a little hotel in Montparnasse called the Hôtel de Chevreuse, in the rue de Chevreuse, a turning off the Boulevard Montparnasse. I thought: "Aha, this is where a romantic painter should be!" and revelled in it. I had an introduction to the sculptor Zadkine, who lived in Montparnasse, given to me by Lett, who with Cedric had known him in their Paris days. Zadkine used to have an open studio once a week at which he dispensed tea. He was a nice old boy, but I was so in awe that I couldn't talk to him much, although he did speak English. It was a rather rich background, which I just absorbed.

'I went to all the museums and galleries and painted, although I didn't get a lot of work done. *Paris, the Seine* was by far and away the best thing, and I did that in my tiny hotel room with the canvas pinned onto the wall and the wardrobe mirror angled to reflect some light on it. I also did café and circus drawings. The circus was exactly the same as when Lautrec did it – a tiny ring, all very close and intimate – and cheap. Everything was cheap.' The 1951 trip to Paris was followed by others when he could get away. Morgan developed a group of friends there, many American. He was briefly married to one, Carole Wagner, an interpreter for international conferences.

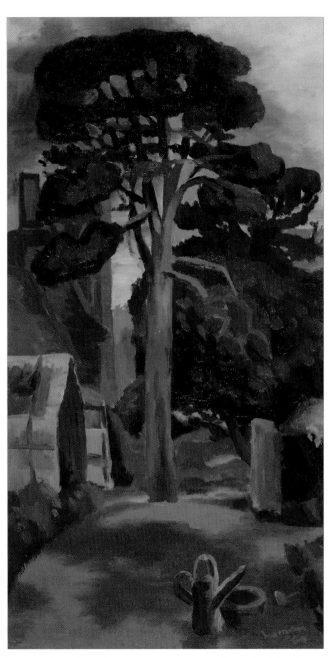

Benton End Garden
1960 oil on board
24 x 12

The 1950s and early 1960s saw the experimenting with style and subject continue. There was a series of birds and animals in a very precise, Van Eyck-type technique and, because models were not readily available, many still lifes. 'At Benton End there were lots and lots of fruit and vegetables and, of course, Cedric loved painting still life, so that was an influence. Still life is a good training. You

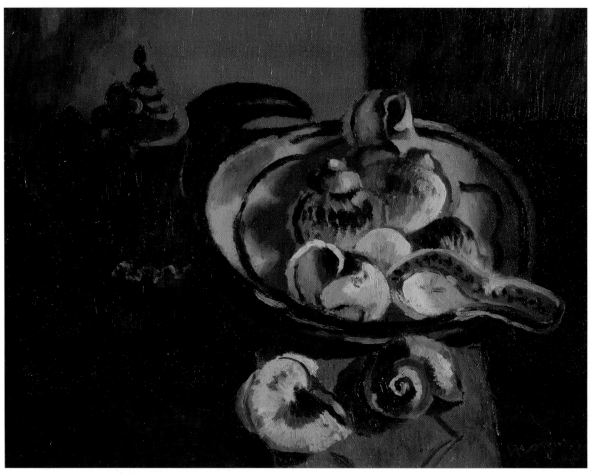

Still Life with Snail Shells 1962 14 x 18

can have something trapped in front of you which is not going to move, shrivel or go away, so that you have to concentrate. *Still Life with Snail Shells*, completed in 1962, was towards the end of the Benton End still lifes, which were all influenced by Braque. Like Cedric, I was very fond of his work. There is a Cubist influence in this picture which I think is very important, dealing as it does with form and not just ideas.'

First Visit to Greece

It was in 1963 that Morgan made his first visit to Greece, which would become a major influence on his work. 'I'd got very absorbed in ancient Greece, having read the *Iliad* and the *Odyssey*, and was getting interested in drawing the human body, which I associated with Greek sculpture. Jean and I took the car, landing at Igoumenitsa, on the west coast. We ordered coffee after our dinner and there was a great ceremony, a waiter followed by a boy carrying a tray. On it was a small tin of Nescafé, which at that time was the thing in Greece.

'Like my romantic notion about Paris, I had this mad, romantic idea that it would be lovely to drive that same night to Athens, and see the sun coming up over the Acropolis. I wasn't sure that it *did* come up over the Acropolis, but I thought it *might*. So we set off, but coming the other way, all night, were lorries loaded with fruit, hurtling along in the middle of the road with no lights. After half a dozen episodes of driving off the road onto the embankment to avoid being squashed, I'd had enough, so we pulled off and slept in the car somewhere, feeling terrible. The first thing we saw in Athens was not the Acropolis but a giant sign advertising Kolynos toothpaste!

'We did enjoy Greece very much. Having the car meant that we could cover a lot of ground. As well as Athens we went to Corinth, the Lion Gate at Mycenae, Ioannina and Cape Sounion. Just as Gauguin was painting exotic pictures before he went to Tahiti, I was interested in Greece and its mythology before I visited the country. It's my belief that an artist doesn't discover a place and then get inspired by it. He finds a place that embodies what he wants to do.'

Further trips to Greece followed. In 1968, Morgan was granted a Goldsmiths' Company Award for six months. 'I wanted a break from teaching and explored various possibilities. The Goldsmiths' Company would finance somebody every year to do some sort of study somewhere on condition that they brought back some tangible proof of it. I had thought of going to Prague, in Czechoslovakia, but then the Russians marched in, so I chose Crete. Jean was then warden of a dig in Winchester, so I went by myself, taking the car and feeling very adventurous. I stayed at a pension where students were put up in a little town called Mallia. The people there had a restaurant and a garden and were very kind to me.

'Crete was a pretty wild sort of place. The brother of one of the people where I lived was a fisherman. He came in one day, when we were sitting around, and emptied a bag of live crabs on the table. They scuttled around for a while, then

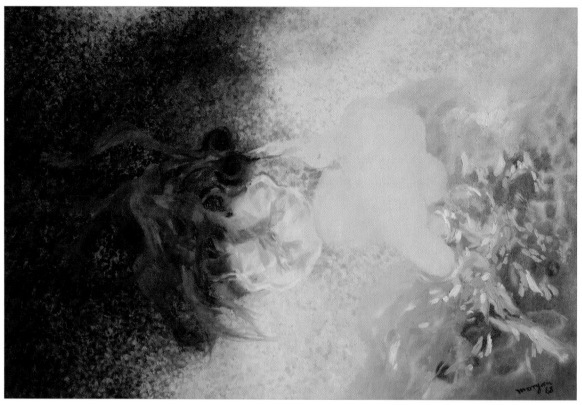

Aphrodite Resting
on the Shore
1968
20 x 30

to my amazement my host, his wife and family started eating them live!

'They gave me a sort of studio up some outside steps to a balcony to quite a
big room, with a door going out onto another balcony with a view of the sea. It
was awfully dark, but I managed. I had a charcoal stove which was rather poison-
ous and tended to put me to sleep. It was so cold some days that I used to stand
over it. I was there until Christmas and during this period the wind blew under
the seaside door and tended to put the fire out. When I told Kostas, my landlord,
that the wind was coming in he came up with a shovelful full of ashes and sprin-
kled them under the door. Of course, next time the wind blew they went all over
the floor – happy days!'

Aphrodite Resting on the Shore, 1968, stemmed from the Crete stay and is one
of the many works that Greece and its mythology spawned over subsequent
decades. 'While I was at the pension, a couple of girl students passed through.
One was very pretty, with long hair, and I persuaded her to pose for me. I did a
couple of drawings of her lying down with her arms above her head, the basis of
a series of pictures. I had not had much chance to draw from the nude. Often
models are not very attractive, anyway. So I delighted to draw her, in spite of the

fact that half-way through her sister came hammering on the door, thinking that I was raping her!' Although it could not be mistaken for work by his Cardiff College teacher, Morgan admits that he 'cannot paint the human figure without being Ceri Richards. It has just sunk into me so deep, and I just make the best of it. Arms and a very thin body and an enormous bottom recur fairly often, so that is obviously to my taste.'

The Table of Minos series followed, which Morgan explains 'was inspired by a krater, or wine-mixing bowl from the Palace of Phaestos, from the proto-Palatial period, 2000-1700 BC, in the Herakleion Museum. A sacrificial offering by the sea produces convulsions in the sky when it is accepted by the gods.' *The Table of Minos VI*, of 1971, is a fine, atmospheric example of the series, although it shows a vase from a somewhat later period. The gouache *Wine Mixing Bowl from the Palace of Phaestos, Crete*, of 1968, is related to the same subject. 'According to the museum, the flowers are intended to suggest the perfume of the wine. I made that the centre-piece of *The Table of Minos*. The bowls vary from picture to picture. A lot of my mature work deals with metamorphosis: Orpheus, Leto cursing the Lycians, Marsyas, The Song of the Earth and Blodeuwedd.' In Morgan's mind, The Table of Minos series paintings are connected with the

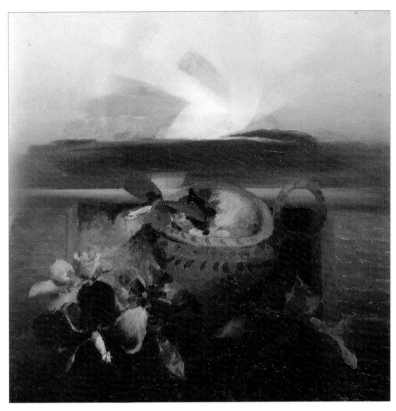

The Table of Minos VI 1971 20 x 20

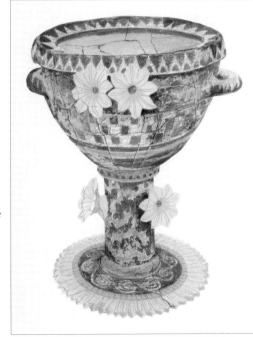

Wine Mixing Bowl from the Palace of Phaestos, Crete 1968 gouache 14 x 11

*Poem in Memory
of Orpheus
1975
36 × 32*

gravel altars, with flowers and leaf offerings, that he had made as a child.

In 1973 he began the Orpheus series, among them *Poem in Memory of Orpheus*, of 1975. 'There were six of these, based on the incident when Orpheus's head was cut off, thrown into the water and floated to the sea still singing. I used a sun shape for the head, with abstract shapes coming off to suggest the music, everything taking place in water with patterns of light and shade.

'The series connected with an idea I'd had for a long time of painting shapes that suggested music. I realise now that it's impossible – or more or less impossible – because music exists in time and painting in space, and never the twain shall meet. However, the idea lingers in my mind, because work I have done since has an element of my original aim. It might have no relevance to the rest of the picture being painted, but I feel that, aged nearly 80, I can put it in regardless of its relevance. Picasso said: "I put the things I like into my pictures, and as for the things, so much the worse for them".'

By now Morgan had progressed from just placing pictures in mixed exhibitions to having solo shows. The first of these had taken place in 1969 at the Drian Galleries in London, an influential venue founded in 1957 and directed by the Polish-born artist Halima Nalecz. It included drawings and paintings done in Greece and received favourable notices. Glyn was now 43, with works in the collections of the Welsh Arts Council and Contemporary Art Society of Wales.

His next solo exhibition, in 1971, was entitled The Table of Minos and was held at The Minories, in Colchester. It comprised paintings, collages and drawings and was dominated by Greek myth-influenced pictures. The *East Anglian Daily Times* critic Freda Constable drew attention to the works' 'inner luminosity' and

'translucent forms', remarking that: 'Without apologies I will state that Glyn Morgan's paintings are beautiful.' In the *Essex Weekly Post* Ray Rushton praised 'an intense colour seduction', reckoned that there was a religious aspect to the work, but also detected a 'feeling of utter loneliness…quite eerie. It is as though one is discovering a land for the first time, or even as though one is the last man on earth or even the man before the first man who is watching creation evolve.'

The next decade would see several more wide-ranging solo and other exhibitions. One painter and gallery owner who gave Morgan a one-man show was the entrepreneurial Richard Demarco, in 1973 in Edinburgh. Morgan had contacted Demarco with examples of his work which Demarco enthused about, although the resulting exhibition did little to forward the artist's career. 'We nearly had a terrible accident going to Edinburgh. I tied a six-foot picture on the van roof-rack, it came undone and sailed into the air over the motorway which could have landed on a car and killed half-a-dozen people. Luckily it landed on the embankment. It then rained overnight when we were staying in an hotel, about five gallons of water accumulating on the canvas which didn't do it much good, although it did dry out in the end.'

A solo show at the Gardner Arts Centre at the University of Sussex followed in 1974, a substantial exhibition of 38 paintings and 24 collages, most of the works stemming from times that Morgan had spent in Greece. Commenting in the catalogue on his achievement, he said: 'All my pictures try to say something about the nature of creation. To do this I use myth, symbol and allusion, since this is the only way I know of doing it.'

In 1978, there was the first of two solo exhibitions at the Gilbert-Parr Gallery in Chelsea, at that time one of the most prestigious places showing contemporary works in the capital. That show merited a notice in the *International Herald Tribune*, whose critic rated it 'a major exhibition'.

Diverse Subjects

THE MIDDLE PERIOD OF MORGAN'S CAREER SAW MORE EXHIBITIONS, including two retrospectives, and a diversification of subjects painted. Dismissive of trendy fashions and unfettered by the restrictions of any art group philosophy, he was free to explore ideas as they occurred.

'In the 1970s and 1980s I seem to have switched between fantasy and imagination and nature. I think the desire was occasionally to come down to earth a bit. If you are doing work from the imagination, like the Minoan pictures, it's all coming from inside you, whereas if you go back to nature with a subject like a lily pond, you are nourishing yourself from nature – refuelling, if you like. I think that is quite important. At Benton End there was a lily pond full of lilies and frogs and I did quite a lot of work around that.'

There were a number of lily pond pictures in the mid-1970s, examples being *Lily Pond with Frogs*, 1975, which Morgan considers 'a successful bit of semi-abstraction', *Frog and Fly*, 1977, and *Owl over a Lily Pond*, 1978. 'That one is rather dark. Although some people don't like dark pictures, I do. In this case I put in the dark background with a roller and included a rather Braqueish bird. Why do I like working in series? Partly because it gives me the opportunity to develop an idea, with variations on the same subject. Again, quite often I don't like parting with a picture, so I've done a pair, selling one and keeping the other. However, I almost always finish one painting before starting another, partly because I like to finish the one I'm working on, and partly because I don't have room in my studio for two or three wet canvases.'

There were more Greek mythological subjects, too. Elements in the pictures disentangle themselves as Morgan explains the imagery. Dating from the late 1970s is the Flaying of Marsyas series of eight collages. Morgan had made his first collage in 1971, *Offering for the Birth of Stars*. *The Flaying of Marsyas VIII* dates from six years later.

Morgan explains: 'Marsyas was a rather dim satyr who one day found a magic flute discarded by Aphrodite. Marsyas found that he could play beautiful music with it, and foolishly boasted that he could do this better than Apollo, who was not only the Sun God but also leader of the Muses. Apollo challenged him to a contest. When Marsyas began doing well, Apollo moved the goal posts, specifying that the winner had to play his instrument upside down and sing at the same time – which Apollo could do with his lyre, but Marsyas could not do with his

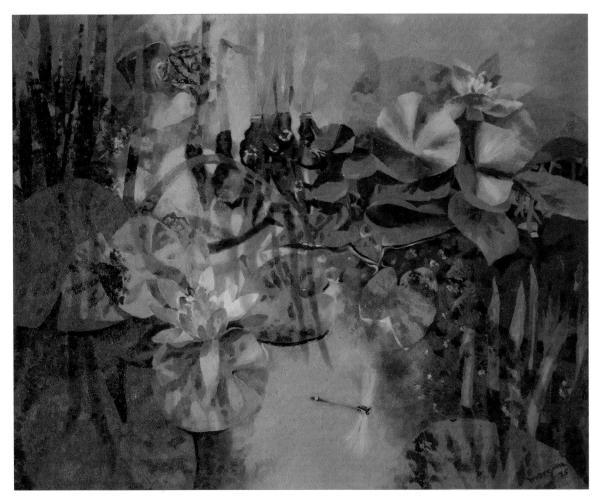

Lily Pond with Frogs
1975 40 × 50

flute – also that the winner could do what he liked with the loser. Marsyas lost and was flayed alive. Some clever people think this is a parable about moving from darkness to light through suffering, but it doesn't seem very likely to me.'

Furthering the mythological theme was *Maenads and Satyrs in the Forest*, 1979, which shows Morgan continuing to experiment technically. 'For that I employed a blocking-out gel, used mainly in watercolours. You put it on, paint over it and when it's dry you rub off the gel, the paint comes with it and gives you a line that has a character of its own.' *Dionysos at Sea*, 1980, illustrated on the cover of the catalogue for his second Gilbert-Parr solo exhibition of that year, is based on a further Greek legend. 'Dionysos was kidnapped by pirates who took him to sea. Tiring of the boat, he turned himself into a lion – note the Ceri Richards-type hand. When the sailors jumped overboard in terror, they were turned into dolphins. Only the helmsman was spared, because he recognised that

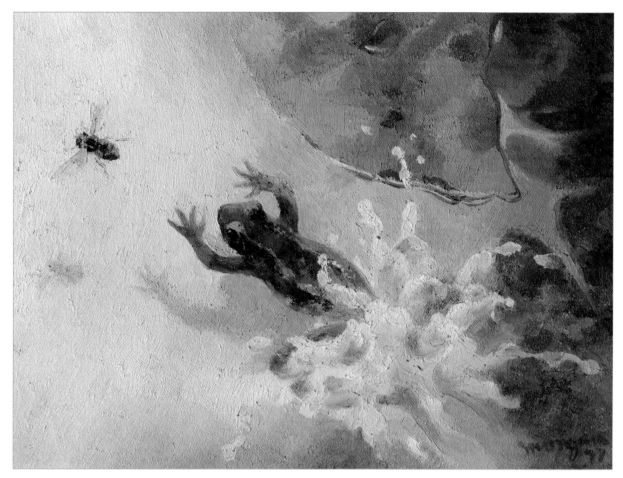

Frog and Fly
1977 10 × 13

Dionysos was a god.'

Morgan admits a fondness for *Leto Cursing the Lycians*, of 1982-3, an elegant canvas with singing, dominant blues. 'This is another one that needs an instruction book. Leto was the daughter of Zeus and one of his passing fancies which made Hera, his wife, jealous. So Leto was expelled from Olympus and she wandered the earth with her two children, Artemis and Apollo – again, note the Ceri Richards hand. She came to Lycia, where she asked for water, and when they refused her she turned them all into frogs.' *Maenad and Owl in the Forest,* which followed in 1984, is a good example of how he contorts the essence of the legend to create the desired visual effect. 'It's an extreme picture, and dark, but I'm fond of it. You can see one leg coming forward, the other leg going back, one arm holding a torch and her stretched neck and hair. There's the owl, and I simplified the forest to a couple of leaves.'

In 1981, Glyn had his first retrospective exhibition, at the Minories in

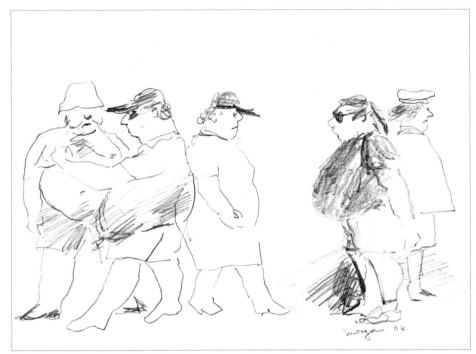

Colchester, a chance to review 35 years' work. There was a strong contingent of Greek-inspired works, with accompanying explanations of the myths. Other pictures indicated that for him the contemporary world had not passed unnoticed, such as *Teddy Boy*, 1956, and *Star Gate*, 1975. Morgan had painted a number of such canvases, related to the highly popular book and film *2001*, using a style which he termed 'an intensified or modified reality.' His great love of music was reflected in the Mahler series, of which *Fantasy after Mahler*, 1979, and the drawing *Gustav Mahler Communing with Nature*, done in 1977, are good examples.

The artist comments wryly on the last drawing: 'In spite of my lofty notions, I think it shows that I do have a sense of humour.' Another example of that humour is the 2004 pencil drawing *Cruise Memories*, showing corpulent passengers on board the liner *QE2*.

Morgan explained in the 1981 Minories retrospective catalogue that the Fantasies after Mahler are mostly based on a story that an eagle carrying a dead crow once flew into the composer's room, an event which would have had a devastating effect on such a man. 'The pictures show the eagle and the crow as symbols of chaos and death. They oppose the forces of light and creativity which appear in the form of shapes derived from nature and musical ideas, and sometimes like Orpheus take the shape of the sun.' He says, laughing, of the story now: 'I have a nasty feeling that it may not be true. Anyway, it made a nice few pictures.'

Dionysos at Sea 1980 50 x 50

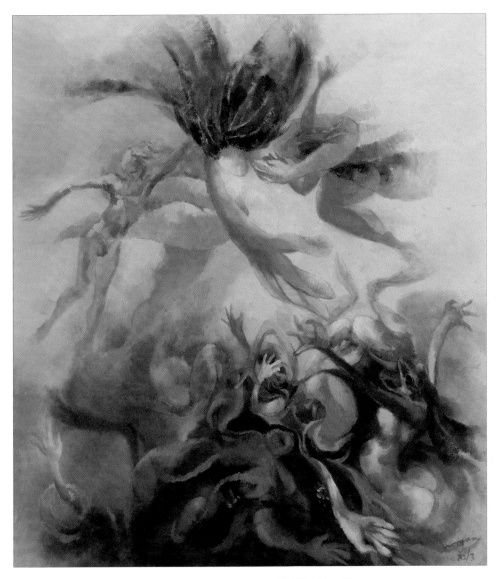

Leto Cursing the Lycians 1982/3 36 × 32

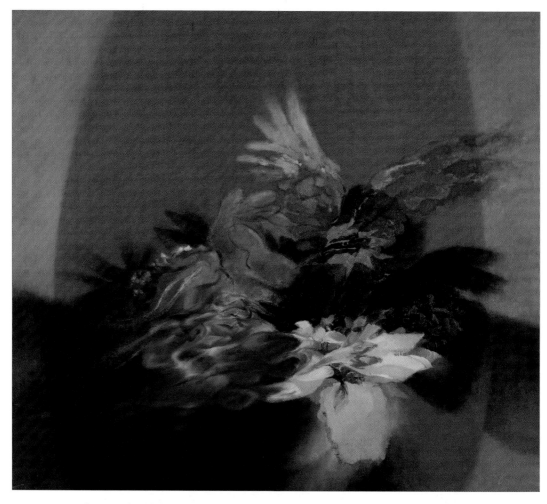

Fantasy after Mahler 1979 32 x 36

A poignant inclusion in the Minories show was the 1981 canvas *Homage to Cedric Morris*, a variation on the 'offering' idea, featuring as it does an iris glowing with light as it is absorbed into the sky. Cedric's companion Lett had died in 1978 and Morris by the time of Morgan's retrospective was enfeebled and would soon die early in 1982. Commenting in his introduction to the catalogue, Ronald Blythe believed that in pursuing his various themes, Morgan had created 'an art which directs us to revelation and light.' In no small measure, this was attributable to Morris's influence on his students, as 'his special gift lay in showing them the rightness of going their own way. To know that he had to do this was the biggest lesson that Glyn Morgan received.'

Another 1981 picture included in the Minories retrospective was *Sea Meditations: Thoughts from the Abyss*. It would form part of the first of the artist's

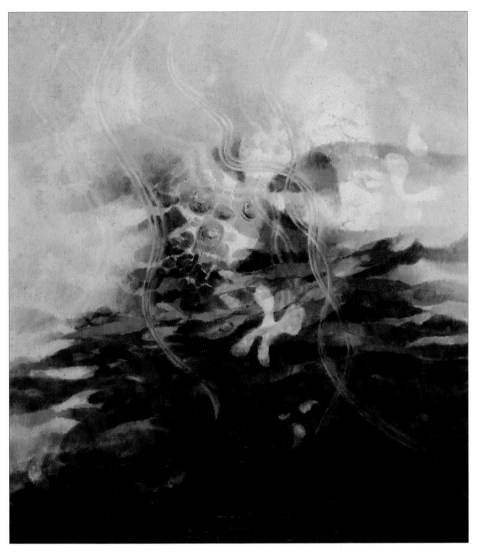

Limpets and Ripples 1981 36 × 32

two exhibitions at the Alwin Gallery, in London's West End, which took place in 1982 and 1983. Morgan had become interested in the patterns of light under water during a holiday that he and Jean had had in Corsica. During this he did some underwater swimming and the result was a colourful show, entitled Sea Meditations, which reflected the Mediterranean as seen from above. The catalogue noted that sometimes Morgan had introduced 'a cube-like shape, a device to imply the gateway to further, more intense facets of reality.' Aphrodite having suggested the element on which the show centred, there was also 'more than a hint of mythology, the related collages dealing mainly with sea creatures rather than the sea itself.' *Limpets and Ripples*, of 1981, is an oil painting in this vein.

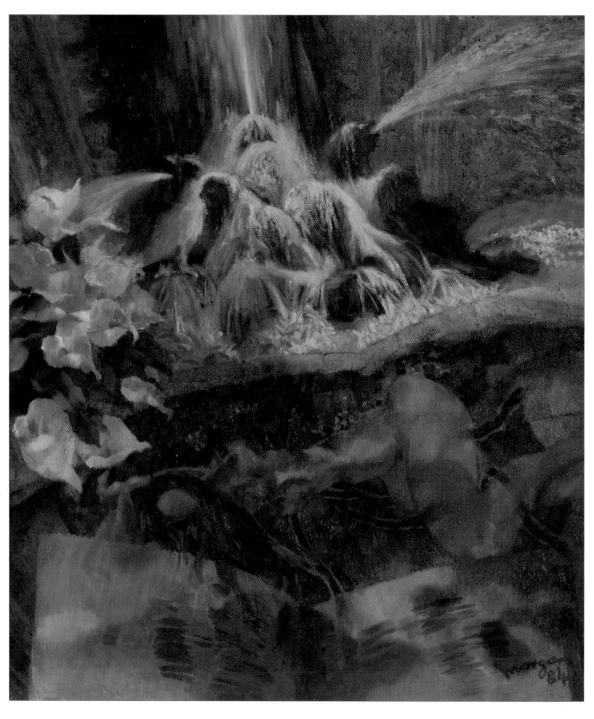

Liszt and Countess Olga von Meyendorff at the Villa d'Este 1984 36 × 32

A Musical Theme

THE MID-1980S SAW MORGAN CONTINUING TO EXPLORE MUSIC ON CANVAS. He listens to BBC Radio 3 all the time he is working. 'I remember when I first got interested in music, when I was 16. I used to walk through Cardiff on my way to art school and would pass a shop where they had beautiful grand pianos all highly polished, and the smell of the polish would roll out through the door. I never learned to play the piano, but they also sold records, and one day I bought my first. I think it was Sibelius's *Second Symphony*, and from then on I was hooked. I learned my music all back to front, knowing Sibelius and Stravinsky's *Rite of Spring* when I should have started on the easy stuff, but I just went on buying records. That was during the war, when you could not get much.

'To play them, I bought an old radiogram covered with bird's-eye walnut veneer, inside which I fitted a motor with Meccano, bought a pick-up through *Exchange and Mart* and put it all together. My taste is still expanding, although my instinctive liking is still mostly for the romantics, still Sibelius, Beethoven's *Fifth Symphony* remains a favourite and now I'm ploughing through his last quartets. About 20 years ago I got to know the music of Mahler and Britten. I listen to anything new, but I'm nearly always disappointed. I do believe that a melody is the most effective way of conveying emotion, which so much contemporary music seems to lack.'

The 1984 painting *Liszt and Countess Olga von Meyendorff at the Villa d'Este* reflects Morgan's love of music and is another one of his pictures that, he says, 'needs an instruction book. It features the Fountain of the Dragons at the Villa, which is a magical place with an enormous garden full of fountains, built by Cardinal Ippolito d'Este at Tivoli, outside Rome. In the nineteenth century it became a sort of retreat for people like Liszt, who wanted to get away from the world.

'There's a story that Liszt was being pursued by the young Olga, he went to the Villa to get away from her, she disguised herself as a gardener's boy, got in and revealed herself to him, so he gave up and took her in. She tells him that she brought a pistol and poison with her, and that if his first words on waking in the morning had been regretful, she would have have killed him.' He laughs. 'Apparently they weren't, so Liszt survived.

'In later years the Villa d'Este fell into disrepair. Now it has been restored, with its fountains working, and is a big tourist attraction.'

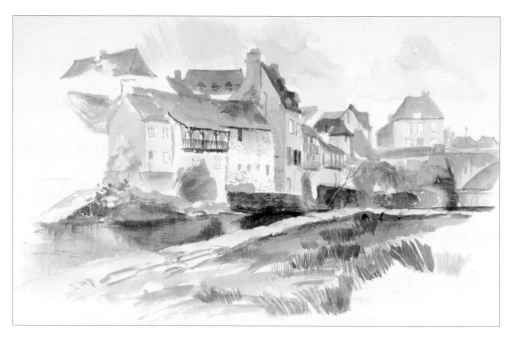

The Dordogne at Argentat c1985 w/c 8 x 13

The mid-1980s were busy years for Morgan, travelling and exhibiting. Some fine watercolours stem from this period. One was *Window at Bottengoms*, a still life of flowers from the garden of the painter and plantsman John Nash's cottage, by this time – 1984 – the home of Morgan's friend the writer Ronald Blythe. From the same year comes *Leningrad with the cruiser* Aurora, followed in the ensuing few years by *Mountain Stream, Brivezac; The Dordogne at Argentat; Venice; Mount Etna; Swimming Pool, Taormina;* and *Afternoon Sun, Corsica.*

'I went with an old school friend to Sicily. Although I don't like flying, we flew. We hired a car, which suited me to drive because he didn't like driving. He knew somebody who had a villa looking across the valley at Mount Etna, where we stayed for a week in a house full of Charles Rennie Mackintosh-style furniture. Have you ever tried sitting at a dining table with a chair with a perfectly straight back? Anyway, our room had a nice balcony and I did some watercolours from it.'

The widespread mixed and solo exhibitions continued. In 1986 Morgan was invited to contribute to the Welsh Arts Council's Invited Artists Exhibition, at Oriel, Cardiff. He showed at the Royal Academy Summer Exhibition in 1987 and 1988, also in 1988 at the Manchester Academy of Fine Art Open Exhibition, the Royal Horticultural Society, Society of Botanical Artists and the Royal Society of Marine Artists.

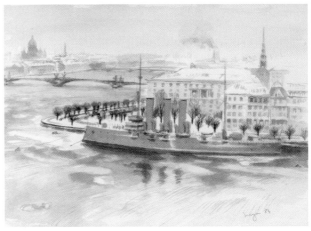

Leningrad with the cruiser Aurora
1984
w/c 10 x 27

One striking oil, painted in 1988 and shown in that year's Summer Exhibition, is the slightly sinister *Brian Collie, David Thomas, Siegfried, Semele and Mrs Fricka-Wotan*. It shows two of Glyn and Jean's opera-loving friends and three singular cats accompanied by the Latin inscription 'Pereunt et Imputantur' ('The hours fly and are counted against us'), taken from a sundial. It was done from drawings and it is a picture that the artist has warmed to over the years.

Morgan showed at two locations in America in 1985, the Archway Gallery, Houston, then at the Charles Phillips Gallery, in Dallas. It was after showing in Amersham, in Buckinghamshire, not far from where he was then living, that Morgan was invited by the gallery owner to show in the Texas galleries. He promised that the sponsorship, transport and organisation would all be taken care of. After attending the Houston exhibition, 'where I think I sold only one picture, then touring round and appearing on local radio, I flew home, leaving my Amersham contact to organise the Dallas show. I realised eventually that my pictures, deposited in a Houston gallery, were not coming back, my contact had disappeared having left a trail of bouncing cheques over Texas, and I never saw him again. After a long delay and no response from the gallery to my letters, a friend, who has a number of my pictures and who was going on holiday with his family to Florida, hired a car, drove all the way to Houston and organised the pictures' return.'

More satisfactorily in 1985, Morgan organised an exhibition that would commemorate what Cedric Morris, Lett Haines and their school had symbolised. As so often with such undertakings, it stemmed from a casual remark.

'I think it was the writer Tony Venison who said to me one day: "Wouldn't it

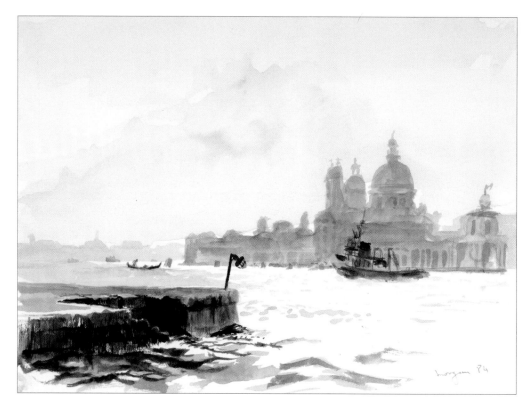

Venice
c1984
w/c 8 x 12

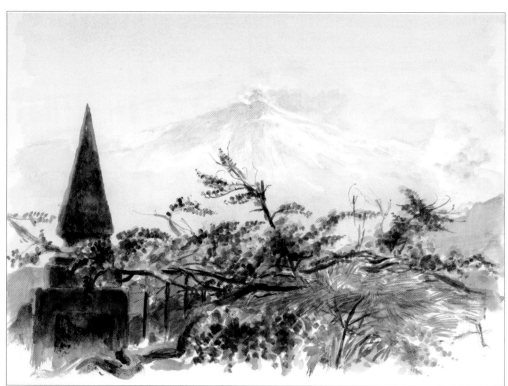

Mount Etna
c1988
w/c 8 x 12

Swimming Pool,
Taormina
c1988
w/c 8 x 12

Afternoon Sun,
Corsica
c1989
w/c 8 x 10

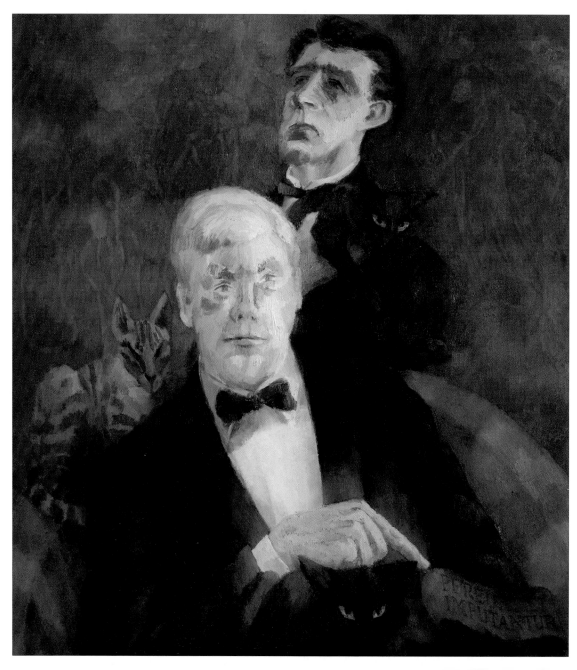

Brian Collie, David Thomas, Siegfried, Semele and Mrs Fricka-Wotan 1988 40 x 36

be nice to have a show of Benton End students?" – so I thought: well nobody else is going to do it, so I will.' Organising the ensuing show, The Benton End Circle, at Bury St Edmunds Art Gallery proved to be a formidable task, with a meagre budget and administrative problems that necessitated Jean hiring an electric typewriter to ensure an accurate catalogue produced to a tight deadline. 'The exhibition was good and everybody was keen to put things in. We had a Lucian Freud and some pictures by Cedric. I don't remember seeing anything in the papers about it, but everyone enjoyed what was a sort of Benton End reunion.'

This was followed, in 1986, by Morgan's second retrospective, which took place at the Taliesin Arts Centre, University of Swansea. Among several oils completed that year were the Wales-based *The Black Mountains* and *Landscape near Llanthony*, with its ruined abbey and strong literary and artistic associations with the diarist Francis Kilvert and the artist Eric Gill. In the way that other Neo-Romantic British artists such as Paul Nash and Graham Sutherland had been influenced by the vision of Samuel Palmer, Glyn says that 'Llanthony Valley became my inspiration as Shoreham was to Palmer.

'I think it was Cedric who introduced me to it. On several occasions when he was visiting Esther Grainger, the three of us went up there in my car and took a picnic. Eventually, Esther left her training college job and lived in retirement in Cardiff. I shared a show with her at the Welsh Arts Council gallery there in 1976. She used to put us up for a weekend or a bit longer, and we loved going to see her, and I used to drive up the valley on my way to Cardiff when visiting her or on my way home.

'What made Llanthony so attractive to me is that it is a closed-in rather narrow valley with a large variety of trees and textures and funny hills, so it is a concentrated landscape. There was a particular hill which Cedric told me of with some delight called Lord Hereford's Knob. I discovered the same hill in a catalogue of Eric Ravilious's work, as he did a picture of it. Its rather Christmas pudding-like shape appears in lots of my pictures.' Morgan completed a pastel portrait of Esther Grainger in 1955, shown at his 1995 retrospective at the Simon Carter Gallery, Woodbridge. When she died in 1990, an important link with Morgan's formative artistic years in Wales was severed.

The 1986 Taliesin Arts Centre retrospective comprised 36 oils and 18 pictures in other media and spanned 40 working years. Reviewing this achievement in the catalogue, Peter Wilcockson drew together the various influences on the artist's work and strands running through them, concluding perceptively that: 'Glyn

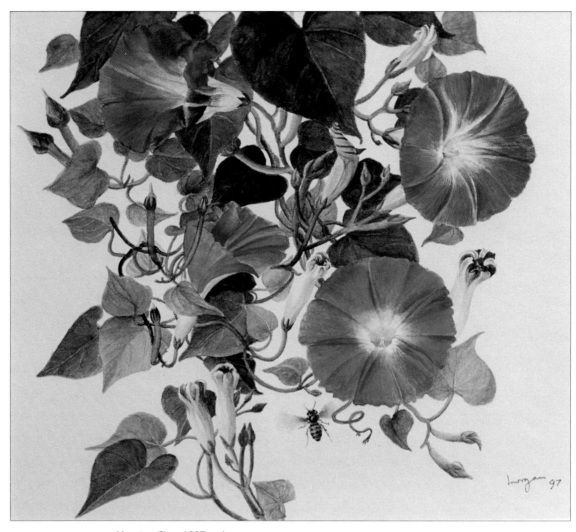

Morning Glory 1997 w/c

Morgan seems to alternate between looking inward and outward, perhaps needing to return to a nourishing observation of Nature between voyages into fantasy … At his wild best, Glyn Morgan is a poet as well as painter and much of his work demands to be read with the same searching attention which one might apply to reading a poem. The subtleties in a good poem emerge only after reading and re-reading and Glyn Morgan's paintings require similar attention from the viewer to divine their profound and unsettling beauty.'

Botanical Artist

BETWEEN 1988-98 MORGAN WAS AN EXHIBITING MEMBER of the Society of Botanical Artists. This might seem an unlikely route for such an imaginative artist to take in his maturity, the chief criterion for many of its members apparently being a strict and rather unromantic regard for minute accuracy. Cedric Morris as well as being a fine painter had also been an internationally regarded, self-taught plantsman, known particularly for his irises. 'I enjoyed the Benton End garden and being in it, but didn't know much about gardening then. I don't know much now. I say I'm the only botanical artist who knows nothing about plants.

'Why did I join the Botanical Artists? By 1988, I was so sick of the art world and all the rubbish associated with it that I thought it would be nice to belong to a group where craftsmanship was really valued. Another reason was a late resurfacing of an interest in Cedric's garden. Although I hadn't paid much attention to it when he was alive, it must have soaked in rather.

'When Cedric died, he left the house to Maggi Hambling. He had discussed with me the idea of me taking it over and continuing it as an art school. That I would have loved to do, although I'm glad now that I didn't. Maggi immediately sold the house and the people who bought it did a bit of renovating. Then they sold it to another couple who were going to do it up some more but sold it fairly quickly. It was bought by the people who are there now, who have done a lot more to it.

'By the time I joined the Botanical Artists the garden had gone. It was getting overgrown when Cedric was still alive, because he couldn't manage the weeding. He appointed Jenny Robinson, who lives in Boxford, as a sort of gardening executor, and she removed all the more precious plants to look after them, then the garden went back to nature. It is now mostly grass with wild flowers, with some of the trees still there. Nobody could make it what it was before. Gardens die with their owners, I think.

'I recall I joined the Society by sending some pictures into their annual exhibition, saying that I would like to be a member. I doubt that they would have accepted Cedric, because his work was not botanical, although it was accurate. Botanical painting is really a thing on its own. After I was a member of the Botanical Society, I used to put work into the Royal Horticultural Society botanical exhibition and won a silver medal several years running. I would never have won a gold medal, because my work was not diagrammatic or scientific

enough. I don't think I could have worked in that way, because I was interested in the colour and texture of the petals, and so on, whereas gold medal stuff is really beautiful diagrams.'

While submitting to the Botanical Society exhibitions, Morgan continued to show elsewhere and explore his more imaginative preoccupation with nature. This was evident in his next two solo exhibitions: at the Quay Gallery, Sudbury, in 1990, and the Chappel Galleries at Chappel, near Colchester, in 1991.

That show, Portraits of Gaia & Other Paintings, featured oils and drawings related to the goddess associated with the earth, worshipped as the universal mother and as the creator of the universe and the first humans. In her introduction to the show, Frances Spalding commented on Morgan's 'rare creative fertility'. Of Gaia, she wrote: 'Mixed in with her benevolence was a vengefulness, for it was at her instigation that Cronus, her son, castrated his father Uranus after he, horrified by their monstrous appearance, had shut away three of their offspring in the depths of the earth.' Spalding found in some of Morgan's paintings 'a magpie-like garnering, of imagery, influences, textures, sensations and memories, which, after being sifted and refined, combine in celebratory fashion with both delicacy and strength.'

Morgan had written to her that as he had worked, 'I became aware of an increasing energy and unease in the pictures which suggested the title. If my landscapes suggest in an oblique way that Gaia is considering getting her own back on us, then they are succeeding. But it's only hints and suggestions. Goddesses don't declare themselves obviously!'

Return to Hadleigh

For 35 years, Glyn and Jean lived in High Wycombe, Buckinghamshire. By the mid-1990s Jean was retiring, so they took the decision to move to Hadleigh, the town near Benton End which had been such an inspiration for Glyn's work.

This was immediately after his second Chappel Galleries exhibition, in 1994, entitled Master & Pupil, Cedric Morris & Glyn Morgan oil paintings. Morgan contrasted their different approaches to making a picture in the catalogue. Whereas Cedric 'was certainly not a conventional draughtsman, and might be described as a sophisticated primitive, my training was an academic one, so any influence he had on me after the first couple of years was one of attitude rather than technique.' Again, 'Cedric's work was remarkably consistent throughout his life, while I experimented with a number of different styles.'

However, there were similarities. 'I suppose we both have in common a liking for heavy impasto, and like him, I often put birds and other creatures in my landscapes. Our pictures are, I think, more remarkable for their differences than their similarities. Mine are mostly concerned with implications beyond appearances while Cedric's work has a steadfast objectivity except for the occasional hint at a secret meaning. As for colour, its expressive use is one of my most important considerations and this is due to his example – he was without doubt one of the great colourists of the century.'

Morgan's third retrospective, in 1995 at the Simon Carter Gallery in Woodbridge – comprising 31 oils, 26 collages and drawings and three watercolours – was a good survey of his 50 active years as a painter, with a hint of what was to come. There were, of course, the series inspired by Mediterranean legends – *Aphrodite*, 1966-68, *The Table of Minos*, 1969-72, *Europa*, 1972, *Orpheus*, 1973, *Apollo and Marsyas*, 1977, *Dionysos*, 1980, and *Gaia*, 1991 – which had spawned works which 'delve into subjects as diverse as the contrasts of sexuality and the nature of water, the latter being the most recurrent theme in his work.' Then there were the stories based on composers, 'such as Liszt in the Villa d'Este Gardens at Tivoli, and the crow-carrying eagle which flew into Mahler's study, symbolising the opposition of chaos and death to light and creativity (1977-9), or the science fiction film *2001* in *Star Gate*, 1975.

'At present he has returned to his native roots and is working with equal vigour on a series based on the theme of the Green Man,' the catalogue concluded. This return to roots would be echoed later with Morgan's series featuring

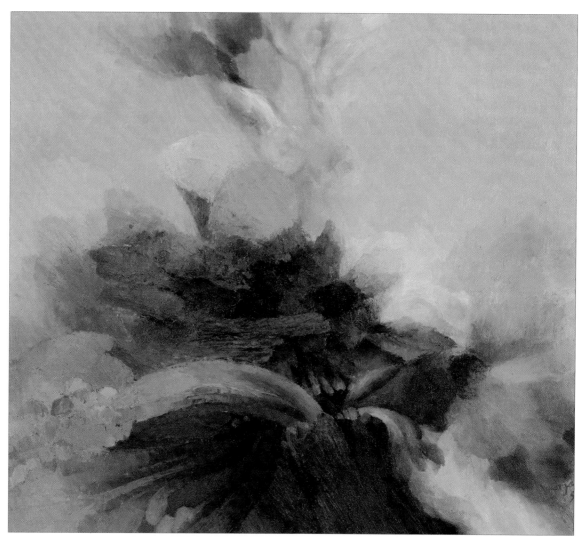

*Blodeuwedd and
the Green Man
1995
32 x 36*

Blodeuwedd, from the *Mabinogion.* At the Simon Carter Gallery the new theme
was represented by one painting: the 1995 oil *The Green Man and the Bird of
Night.* The Green Man would be a leading feature of that surge of Glyn Morgan
exhibitions that took place after the Simon Carter retrospective. These shows, an
impressive performance for a man entering his seventies, comprised in 1996 a
seventieth birthday show at Chappel Galleries; 50-year reviews at Oriel Llundain,
London, 1996, and Rhondda Heritage Park in 1997; plus in the latter year a
retrospective at Y Tabernacl, The Museum of Modern Art, Wales, in Machynlleth.

By the time of the 1996 Chappel Galleries show, entitled The Green Man,
Morgan had assembled enough pictures to make an exhibition based on this
pantheistic theme. The original inspiration for Glyn's pictures was William

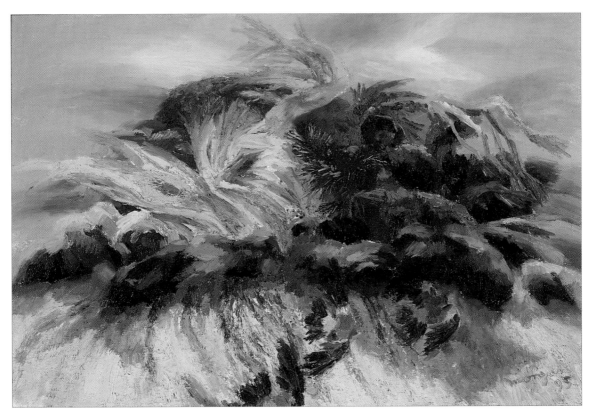

Anderson's book *Green Man: The Archetype of our Oneness with the Earth*, published in 1990. For Anderson, 'The Green Man signifies irrepressible life. Once he has come into your awareness you will find him speaking to you wherever you go…The Green Man, as a composite of leaves and a man's head, symbolises the union of humanity and the vegetable world. He knows and utters the secret laws of Nature…The Green Man has returned as the living face of the whole earth so that through his mouth we may say to the universe: "We are one".'

Morgan recalls: 'With the series, I found myself back where I started, with mystical landscapes inspired by Palmer, Nash and Sutherland. In their work I saw a presence in nature which was a sort of poetic reality which transcends realism. Cedric said that realism is not reality, and Lett was fond of saying: "Without distortion there can be no art", which I take to mean that simply copying a subject leaves no room for creative interpretation. The Green Man fits into this very well. Of course, I could not go into the woods and sketch the Green Man, so I had to use carvings and pictures in various cathedrals and churches' – Norwich cathedral and Bulmer church have good examples – 'but by the time I had finished with them they were quite different.'

*The Green Man
in a Wood –
Winter Sunrise
1995
20 x 30*

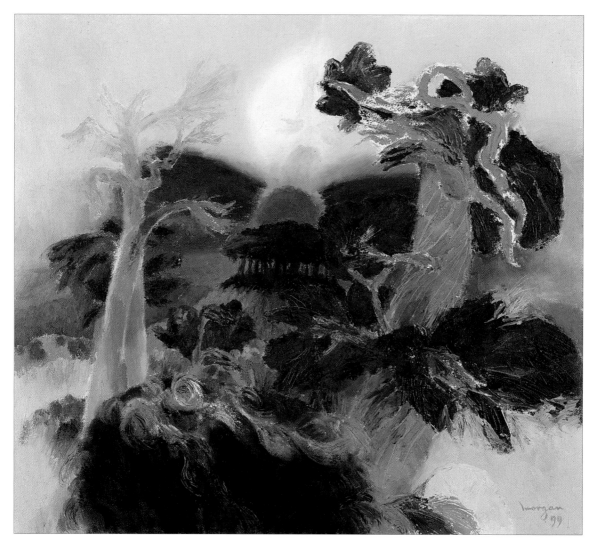

*The Barrow of
the Green Man*
1999
32 x 36

In the Chappel Galleries catalogue Morgan's friend Ronald Blythe instinctively appreciated Glyn's allusive handling of the subject and noted the Green Man's topicality. 'Often feared in the past due to what was thought his rivalry to Christianity, he has in our own ecology-conscious world emerged to a new understanding of what he has stood for from the earliest centuries until the present. The poets, sculptors and wood-carvers have never forgotten him and now, along with the goddess Gaia, we recognise him afresh as we struggle to deal with an endangered Earth…Glyn Morgan's success in suggesting the Green Man's presence rather than directly stating it is evident in these beautiful pictures.' *Blodeuwedd and the Green Man* and *The Green Man in a Wood – Winter Sunrise*, both painted in 1995; *The Green Man at Seed-time*, 1996, with its joyous use of sunflowers, con-

sidered by Glyn 'probably the best of the series' and used to illustrate the cover of the Chappel Galleries catalogue; and the later *The Barrow of the Green Man*, 1999, with its Paul Nash-like Wittenham Clumps in the distance and a fiery setting sun, are fine examples of the series.

Morgan had three shows in 1998: at Chappel Galleries, Brecknock Museum & Art Gallery in Brecon and one at the John Russell Gallery, Ipswich. Helen Clarke reviewed the Chappel Galleries and John Russell exhibitions in the *East Anglian Daily Times*, noting that the latter 'took the form of a retrospective'. Although Morgan's early works seemed 'darker, heavier, more earthbound' than the contemporary 'huge canvases filled with flowers, seedheads, toadstools and foliage, all flooded with a radiant, rather unearthly light', she detected in the 1946 picture *Porth, Rhondda* 'the light breaking through [that] has that same bright radiance.' Together, 'the two shows offer a superb portrait of a man and his work.'

Mindscapes

A GLANCE AT A LIST OF THE MANY PICTURES MORGAN HAS PAINTED since the mid-1990s indicates a continuing preoccupation with myth and legend but also a strong landscape theme. 'My pictures are changing slightly. The landscapes have become less variations on a known if romanticised landscape and more landscapes of the mind. What I'm trying to do all the time is to become more abstract. I don't much go for pure abstract painting, as I feel it's like music without a tune. I want to make it more musical, perhaps. The pictures are getting more internalised. Lately, I have been doing a series based on the story of Blodeuwedd, in which the landscape is something in the background, and I think this has enabled me to take the abstraction a bit further.'

The legend of Blodeuwedd, which preoccupied Glyn from 2004, is taken from the *Mabinogion*, a collection of mostly fourteenth-century Welsh stories, considered by many scholars to be the most artistic expression of the early Celtic genius. Although Morgan's father was Welsh, his mother was English 'and rather looked down on anything Welsh. I chose not to do Welsh at school, and there was never much Welsh spoken then in South Wales, whereas today I believe it is compulsory. No one much outside Wales reads the *Mabinogion* and I do occasionally laugh at it, but I hope a lot of Welsh people will read it. Most mythologies are a bit over the top, but they are nonetheless potent. The story of Blodeuwedd is a bit ridiculous, but very pictorial.

'A Welsh prince wanted a wife, so the resident magician made one for him out of flowers – Blodeuwedd means flower-faced – which delighted him, and everything was fine for a while. One day, Blodeuwedd saw another Welsh gent passing by hunting, she fell for him and they had a secret affair. She decided to get rid of her husband, but there was a problem, as he was protected by the magician. The new lover suggested she try to find a way round this, so Blodeuwedd, saying she worried about him, asked her husband if there was any way anyone could kill him. He replied that, yes, there was one way: with a spear cut from a certain tree at a certain time of the year when he was about to get into the bath with one foot in it and the other on the back of a goat.

'This the lover managed to do, whereby the prince turned into an eagle and flew away squawking. The magician heard. He also learned that, on a farm not far away, a certain pig went out every night on a mysterious errand. One night he followed it to a tree underneath which there were lots of juicy maggots that the pig

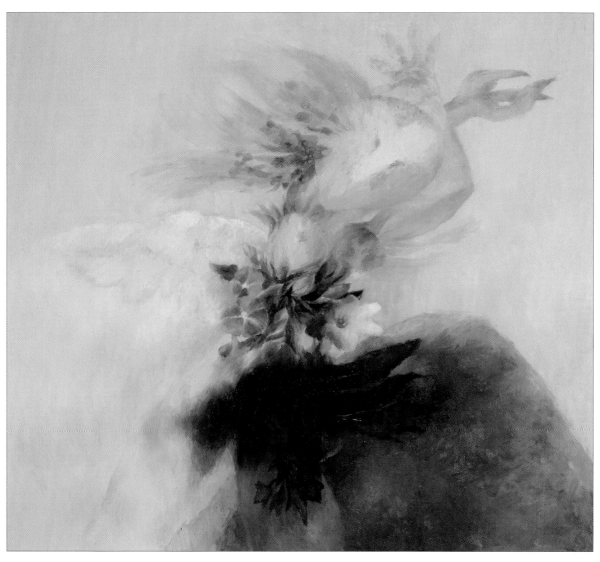

Blodeuwedd IV 2005 40 × 45

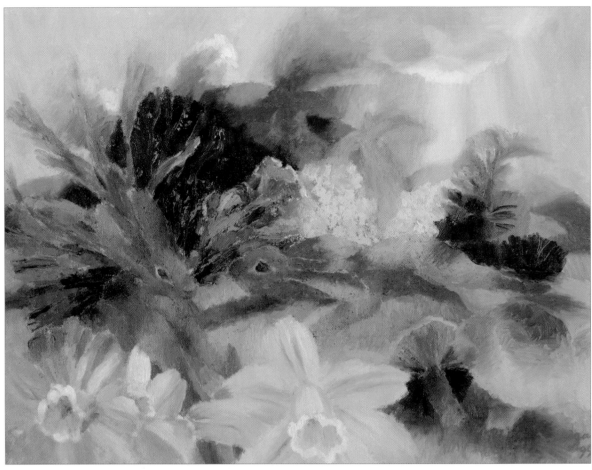

Spring Symphony 1999 24 × 32

enjoyed. The maggots were dropping from the feathers of an eagle on top of the tree, which was the transformed prince. So the magician called the eagle down, tapped it with his wand and he was turned back into a prince. Blodeuwedd had to be punished, so she fled with some of her maidens who were all looking over their shoulders, except her, so ran into a lake and were drowned. Blodeuwedd was turned into an owl.

'My series of pictures based on the story combines woman, owl and flowers, and I think they have turned out quite well. In *Blodeuwedd I* I think I've managed to get a tragic look into her face, as much as to say: "Why are you doing this to me? I've only been a naughty girl!"'

Landscape was a strong thread running through Morgan's seventy-fifth anniversary exhibition in 2001, when the Chappel Galleries published one of its series of illustrated monographs on the artist. *A Vision of Landscape: The Art of Glyn Morgan* had a fine introductory essay by Ronald Blythe, whose portrait,

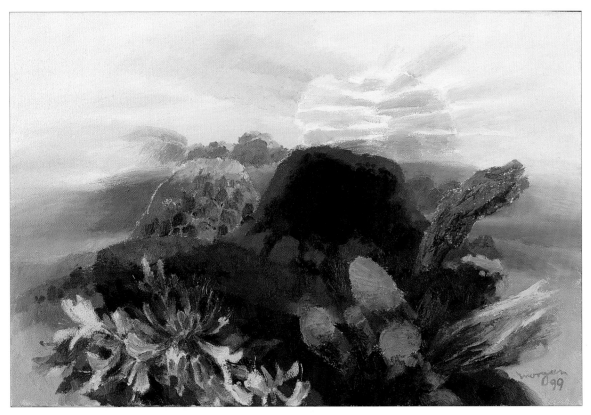

Landscape with Honeysuckle 1999 20 x 30

painted by Glyn the following year, was acquired by the University of Essex. The monograph's illustrations mainly feature the later landscapes, and include the richly coloured *Landscape with Setting Sun*, 1997; the more subdued *Autumn Wood, Suffolk*, 1997; the exuberant *Spring Symphony*, glowing *Landscape with Honeysuckle* and reflective *Midsummer's Eve*, all of 1999; and from 2000 *Landscape with Flying Birds, Owls under the Moon* and *Landscape Motifs I-VIII*, with their diverse references to nature.

Morgan approaches landscapes such as *Autumn Wood, Suffolk*, with preparatory drawings on location – in this case, one of the few done of what is now his home county – and then worked up in the studio. 'Nowadays, it is physically difficult, if not impossible, for me to paint on the spot. When I have done it, the result was always rather dull and academic.' *Spring Symphony*, celebrating recovery from a serious illness and nasty operation to overcome peritonitis, is a suitable medley of motifs from this most optimistic season backed by sun coming up behind a cloud. Glyn does not deny the influence of Paul Nash in *Midsummer's Eve*, with its mysterious light, and reflects: 'I don't know if it's

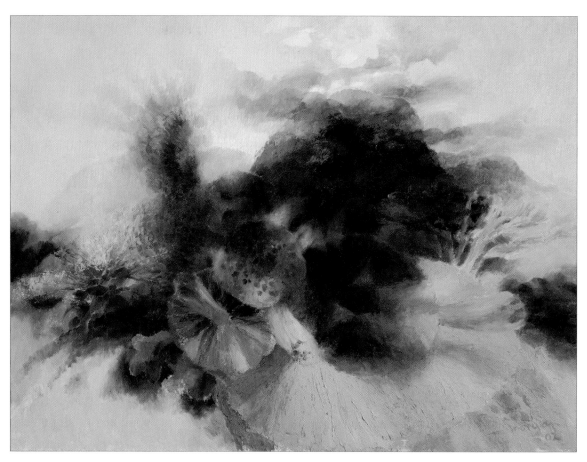

Song of the Earth II
2002 36 x 48

hubris or not, but nowadays when I think I've done a particularly good one, I look at something by Nash, Sutherland or somebody else and think, to my surprise, "I'm as good as that." It's a nice feeling, but I always have a faint suspicion that I'm fooling myself...

'The Blodeuwedd pictures are based on drawings where I worked out a few ideas years ago, but sometimes ideas for pictures go back decades. One of my best Song of the Earth series paintings was based on a drawing I did in the fifties. I have lots of sketchbooks full of notes. Because of my knees now I can't walk in the countryside and explore. If I do go out I have to stay in the car, which is probably another reason the pictures are getting more internal. One odd thing – odd even for me – is that I did some drawings for the Orpheus series in which part of the subject was a curved heart shape which represented Eurydice, with her lower back, legs and bottom. I found one of those drawings last year and suddenly realised that if I turned this shape upside down, I had the face of an owl, on which I was able to base some of the Blodeuwedd series.'

Studio Battlefield

When David Thompson, who wrote the introduction for Morgan's 1996 Oriel Contemporary Art show, visited the artist's studio, he was fascinated by the contrast between the 'teeming, convoluted, unpredictable, exuberant and (I use the word advisedly, for it's his own) wild' nature of the work and where it stemmed from. For Morgan 'presents the very model of the methodical craftsman – the workplace clean and orderly, primed canvases at the ready, tools and paints to his right, sketchbook pages (of an exquisite and barely legible minuteness) with other reference material to his left, impressively stocked CD player against the wall.'

Ten years on, there are no signs of these high standards being relaxed. Working towards his 2006 National Library of Wales retrospective in Aberystwyth, Morgan says: 'I'm not as regular as I'd like to be in the studio, but, depending on the light and how I feel, I try and get in between four and six hours a day. After that, the spark begins to fade. I'm not very good in the mornings and don't come to life before 11am. Generally I work in the afternoon, although sometimes I can get a bit done before lunch and, when the days get longer, do a bit after tea as well. Ideally, I work seven days a week, although sometimes other things intrude.

'I do a rough drawing in charcoal, then an underpainting which blocks in the main colours and tones with thin paint mixed with turps. That takes a day or so to dry, and then I go ahead with the actual painting. I try to make that the final painting, although sometimes something has to be scraped out and altered.'

In 1994 Morgan wrote: 'My pictures were, and still are, a battlefield,' on the occasion of the Master and Pupil show of his and Cedric Morris's work at the Chappel Galleries. He contrasted this with Morris's apparent ease of execution, with everything balanced, made possible, he feels 'because basically he was a realist – a sort of realist, anyway, whereas I am dealing with other sorts of vision.' A dozen years on, 'they're not so much a battlefield now, but I probably would never achieve what he did, because although his canvases were transformed, he was always doing what was in front of him.'

Morgan believes the presentation of a picture to be most important and often does most of the work himself. 'The appearance of the mount and frame make such a difference. I have noticed with amateurs that they don't put a heavy enough frame on pictures and so spoil the effect. I use a framer in Ipswich sometimes. Mainly, for the oils, I use a joiner I have got to know who, provided it's a

minimum 200 feet of moulding, will cut it and put frames together to suit my measurements, then I paint the frames to suit the pictures. It's a little bit cheaper that way, and I have more control over what frames will look like. Every two years, perhaps, I get another load of frames from him.'

Earth Song

THE SONG OF THE EARTH was the title of Morgan's Chappel Galleries exhibition in 2004. During the years since his last solo show, in 2001, Morgan had steadily worked on a stream of impressive new canvases, apart from holidays, during which, he insists, 'nothing I do is important'. The landscape theme continued in 2001 with such works as *Landscape with Fungus*, *Winter Wood* and *Landscape with Sunflowers*. *Landscape with Fungus* was done 'particularly for the light, nice and luminous. I've done a lot of fungus pictures – there was another completed in 2002 – and I've often used a chopped-off tree stump as a sort of table, which leads back to my 'offering' pictures. This recurring theme is more or less unconscious. I think there is a very good light in *Winter Wood*, with the nightjar flying in the foreground. I like to do a snow scene from time to time.'

The transformation of familiar motifs, such as fungi and sunflowers, into pictures is evidence that, in his seventies, Morgan remains flexible in his approach. 'We have had sunflowers in the garden from time to time and I brought one back from France, stopping the car by a field and hacking one down. Colour has become more important as I've gone on. Cedric taught me about it, and one thing he said was to take two different colours side by side which are the same tone and the effect is dazzling. I've done it here. Nobody knows these things now. Nobody teaches them.'

The methods by which a particular texture is achieved, as in the fiery *Landscape with Sunflowers*, can be unconventional. 'Sometimes by mixing sand in the paint or fluff out of a washing machine tumble drier.' *Landscape with Sunflowers* is unusual, too, for its use of red, not a familiar colour in Morgan's work, as he finds it 'so strong. It's also very expensive! I've had a tube of cadmium red for about 40 years and I use a little bit from time to time.' Morgan would return to his sunflower theme in 2003 with *The Flight of the Sunflowers*.

In two other 2001 pictures, *The Destroying Angels I* and *The Destroying Angels II*, fungi take to the air and assume a vengeful guise. 'I have a book about fungus that explains that mushrooms are either edible or poisonous. These are deadly apparently, and I show them in full flight, off to poison someone. I thought that deathly white was a suitable colour for them, accompanied by death's head hawk moths.' There's menace, too, in the 2002 canvas *The Valley of Owl Spirits*, but in *The Dance*, completed that year, fungi have assumed a playful guise.

Morgan explains that the major Song of the Earth series, begun in 2003 and

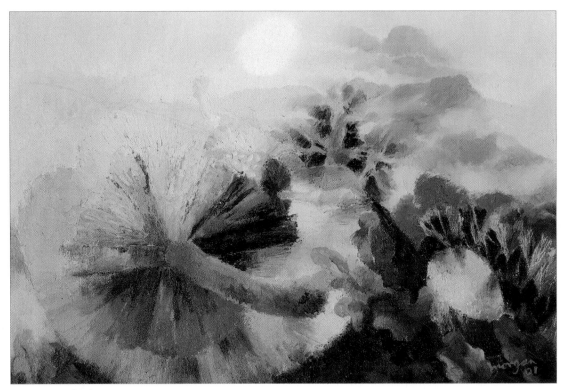

Landscape with Fungus 2001 20 x 30 *Winter Wood* 2001 20 x 30

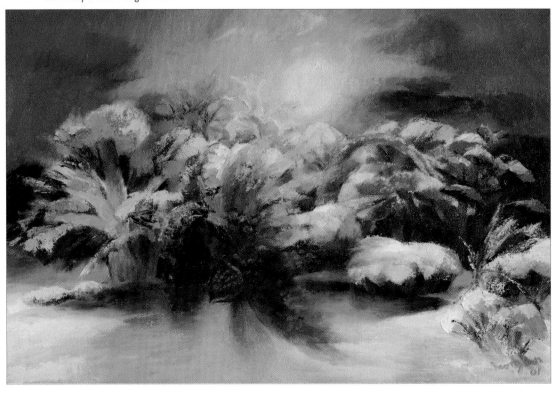

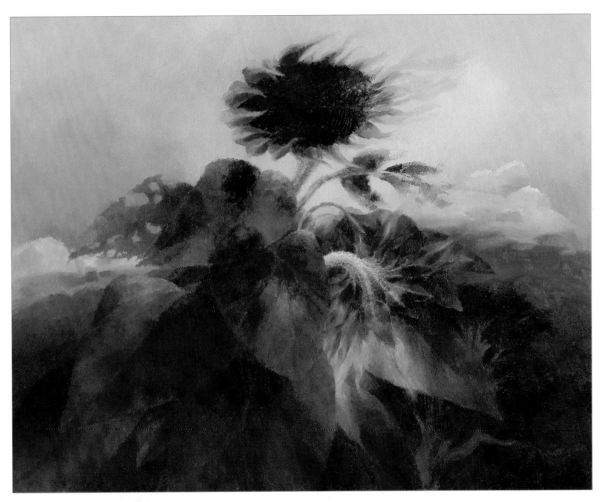

*Landscape with
Sunflowers
2001 40 × 50*

shown the year after at the Chappel Galleries, was not, despite his love of the late romantic composer Mahler, based on his famous composition. 'I just thought it was a suitable title for landscapes basically as before, except that they are a bit more abstract and so more musical.' An interesting diversion in 2003 was *Cycle Path in Aquitaine*, reflecting Glyn and Jean's love of France and its peaceful, empty landscapes.

Landscape remained a strong theme in Morgan's 2004 output, as in *Landscape with Fungus* and *Landscape with Kites, Ceredigion*, 'done from a sketch on the way home from Aberystwyth', and in the eight *Landscape Motifs*. These were an exciting new development, oil and collage on board, whereas his canvases are usually large, once framed creating a storage problem. A series of *Landscape Motifs* in collage, watercolour and pastel followed in 2005. After his first tiny collage in 1973, *Offering for the Birth of Stars*, and the two other 1970s collages

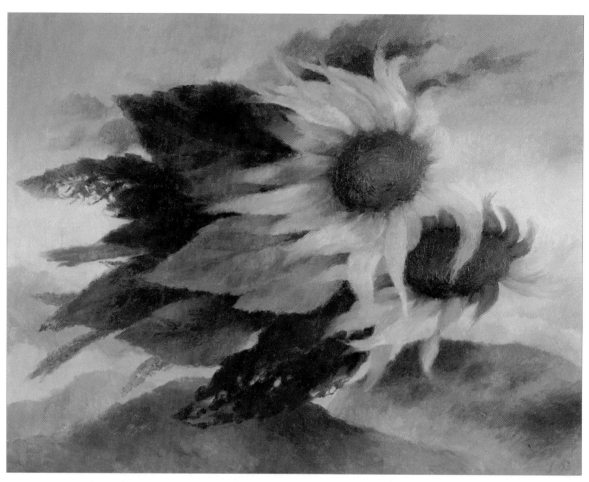

The Flight of the
Sunflowers
2003 28 × 36

already cited, *The Flaying of Marsyas VIII* and *Fantasy after Mahler,* this was a medium to which he has periodically returned. Examples are *The Fountain of the Tortoises, Rome,* and *The Pantheon Fountain, Rome,* both 1982 and exhibited in the second Alwin Gallery one-man, The Fountains of Rome, in 1983; also the *Apollo & Daphne I-IV after Bernini* series, of 1999, and *Apollo abducting Kyrene,* completed in 2000.

The Song of the Earth series was well advanced by the time of Morgan's 2004 exhibition of New Paintings at the Martin Tinney Gallery in Cardiff. Richard Morphet, former keeper of the modern collection at the Tate Gallery and an expert on Cedric Morris and his circle, was an apt choice to write the catalogue foreword reviewing Morgan's achievement. He divined debts to Ceri Richards, Cedric Morris and Arthur Lett-Haines in Morgan's preoccupation with such themes as water, music, the thrust of organic life; vibrant colour and with plants, animals and birds; and with mystery and metamorphosis. Observation and the

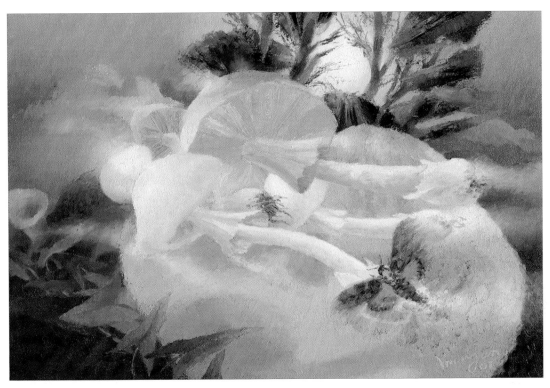

The Destroying Angels I 2001 20 × 30

The Destroying Angels II 2001 22 × 36

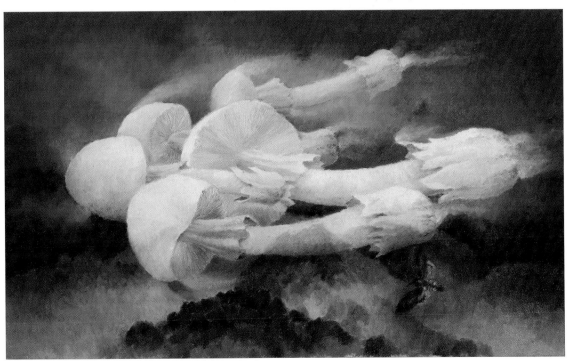

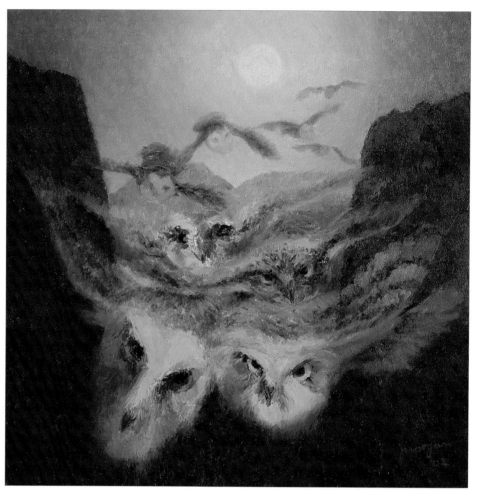

The Valley of Owl Spirits 2002 30 x 30

sensuous properties of paint were key properties which, as his work developed, had 'become richer in both these respects.' There was 'a preoccupation with extensive time-spans' in art that was 'true, too, to a Welsh tradition of dream and imagination.'

In the introduction to his 2001 Chappel Galleries exhibition catalogue, Morgan had found it timely to reaffirm his long-held belief that 'the primary purpose of art is to uplift the human spirit, and I think that most people would agree that this uplift is needed probably more now than it has ever been.' He was sure that 'any merit my work may have is immeasurably strengthened by a sound technique and the sense of being in a tradition which has produced many great painters in the past.'

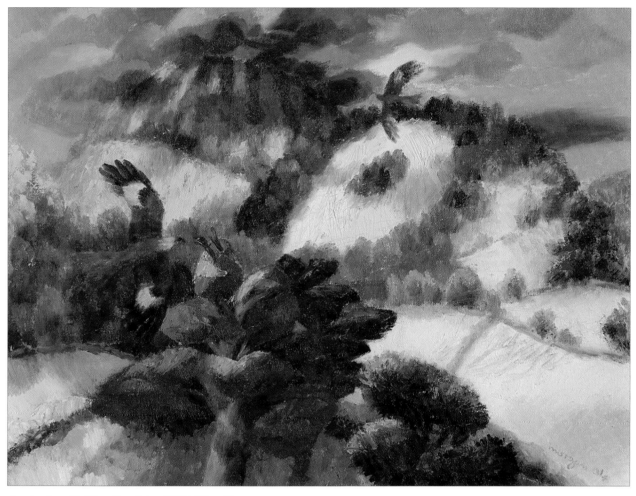

Landscape with Kites, Ceredigion 2004 30 × 40

He lamented that these 'traditions have been destroyed or disregarded'; that much claiming to be art was 'a collection of adolescent pornography and – literally – a pile of rubbish' and that many major art schools 'seem to have abandoned the teaching of techniques in drawing and painting; indeed there are probably few people on their staffs who are able to teach them. Perhaps the most sinister aspect of this scenario is the cold-blooded negation at its heart. It does not uplift the human spirit. It denies it…All may yet be well if those who are aware that the Emperor's New Clothes are imaginary continue to see clearly and speak out.'

Morgan concluded: 'The dying artist in Shaw's *The Doctor's Dilemma* summed it up admirably: "I believe in Michaelangelo, Velàsquez, and Rembrandt;

The Fountain of the Tortoises, Rome 1982 collage 19 x 22

in the might of design, the mystery of colour, the redemption of all things by Beauty everlasting, and the message of Art that has made these hands blessed. Amen." I don't think I can improve on that.'

oils

Berw Pool, Pontypridd 1950 28 x 36

Paris, the Seine 1951 28 x 36

Cedric Morris in his Garden c1957 board c.20 x 25
[Collection: Ipswich Borough Art Gallery & Museums]

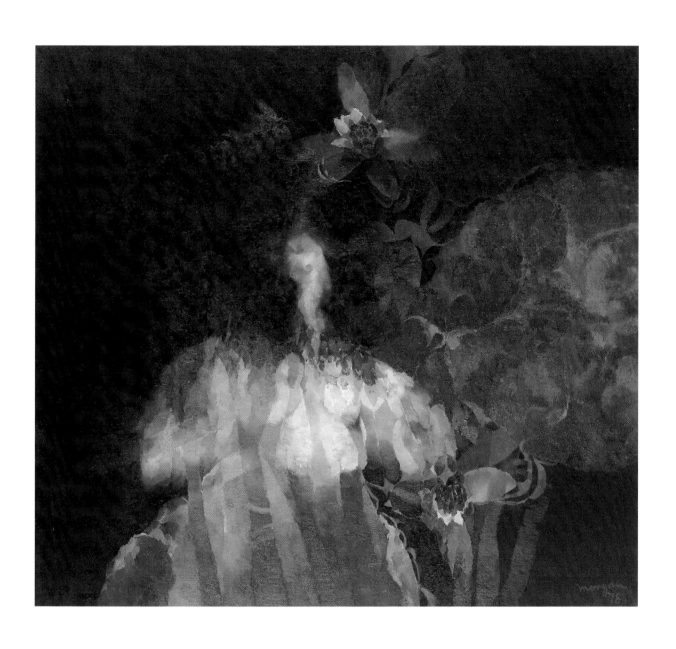

Owl over a Lily Pond 1978 45 x 50

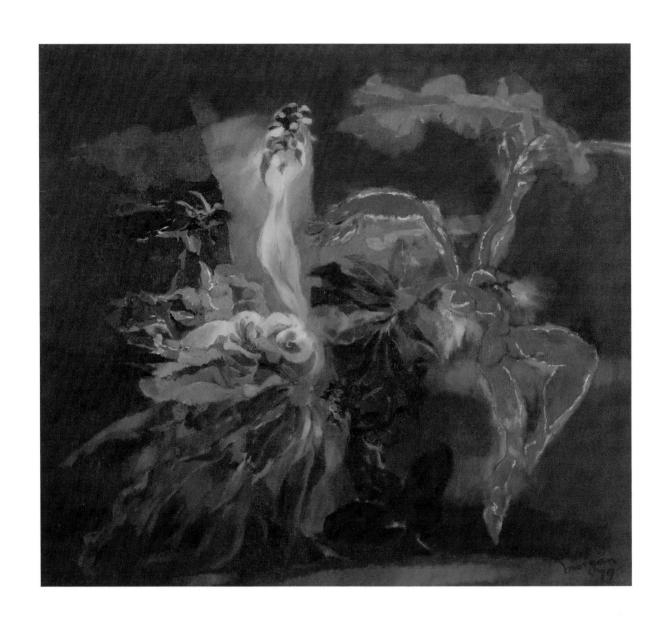

Maenads and Satyrs in the Forest 1979 32 x 36

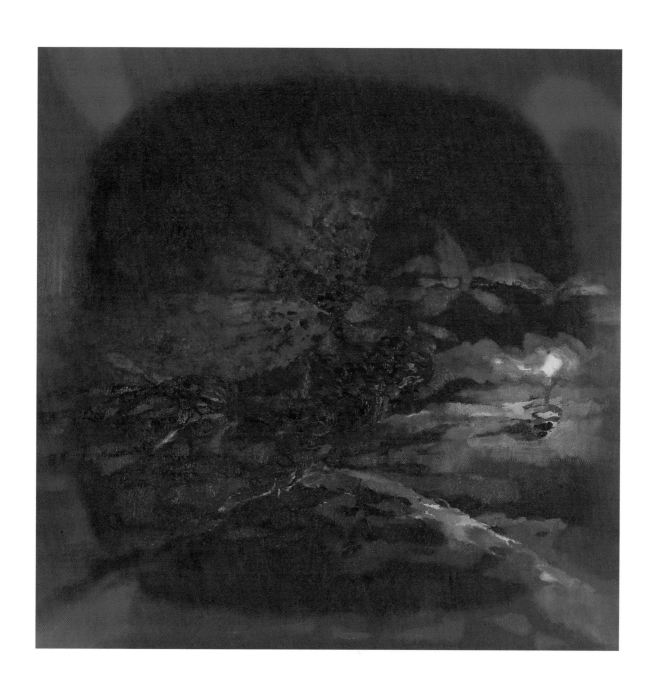

Maenad and Owl in the Forest 1984 36 x 36

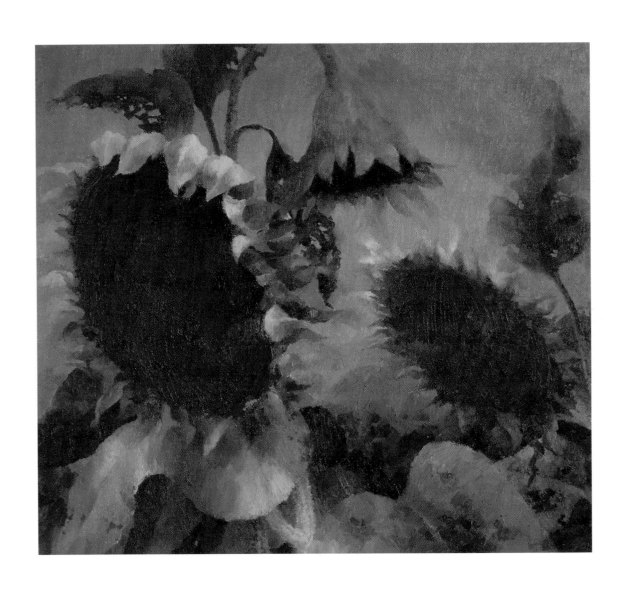

The Green Man at Seed-time 1996 32 x 36

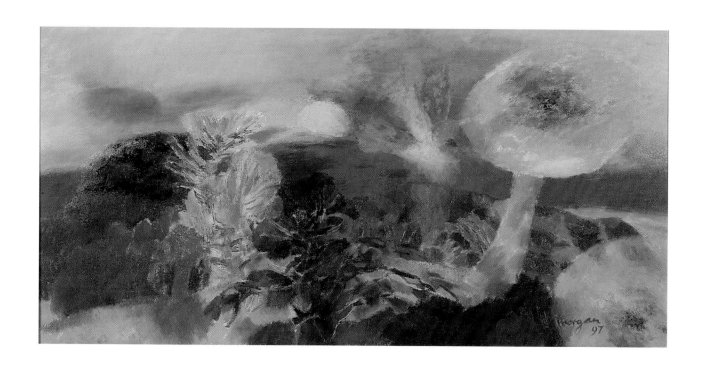

Landscape with Setting Sun 1997 24 x 48

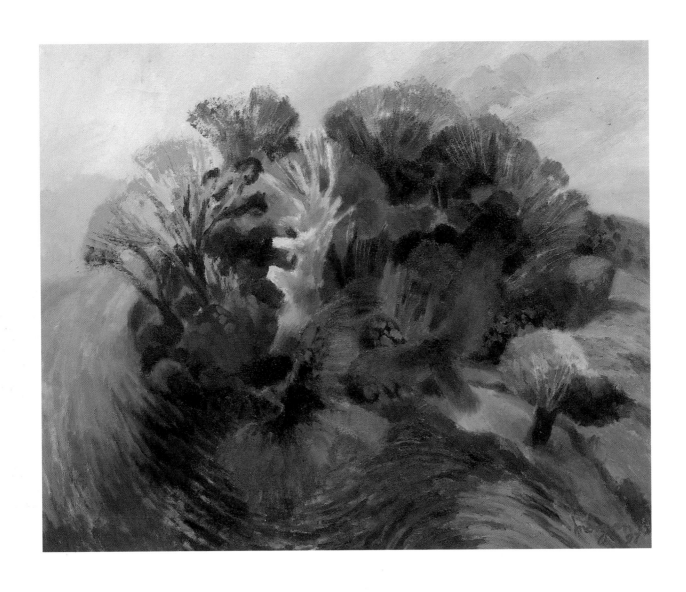

Autumn Wood, Suffolk 1997 24 x 30

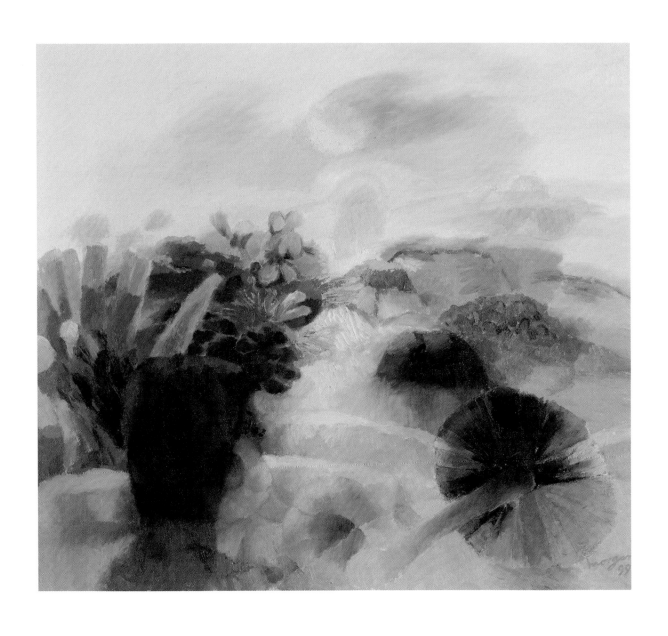

Midsummer's Eve 1999 32 x 36

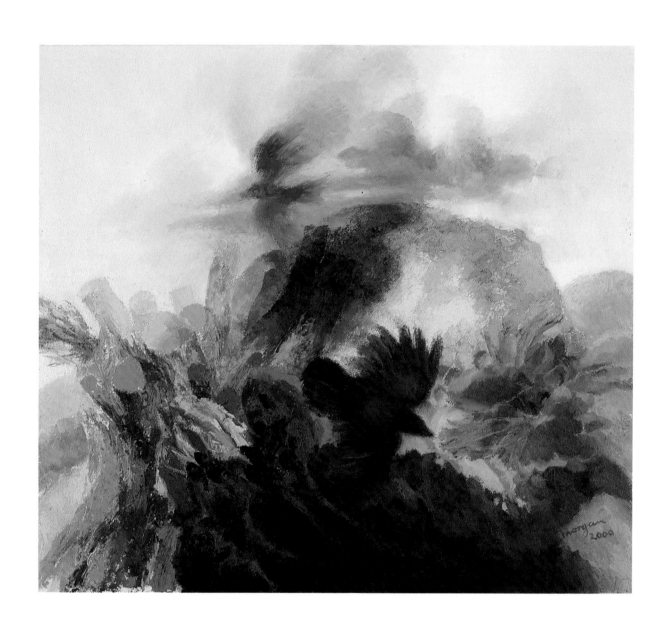

Landscape with Flying Birds 2000 32 x 36

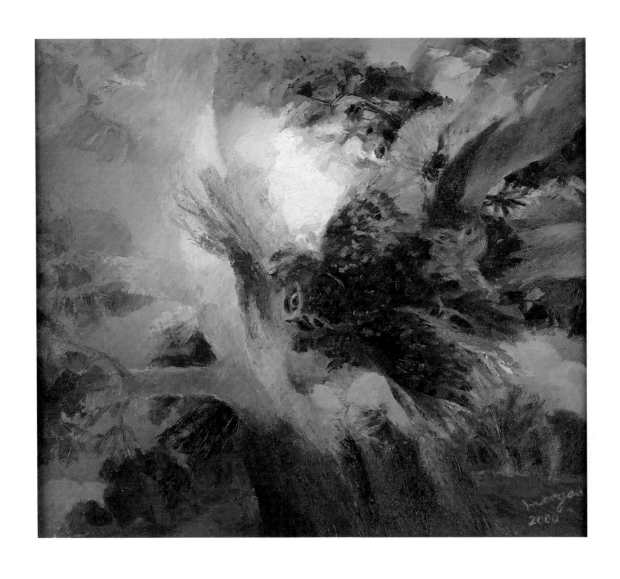

Owls under the Moon 2000 30 × 30

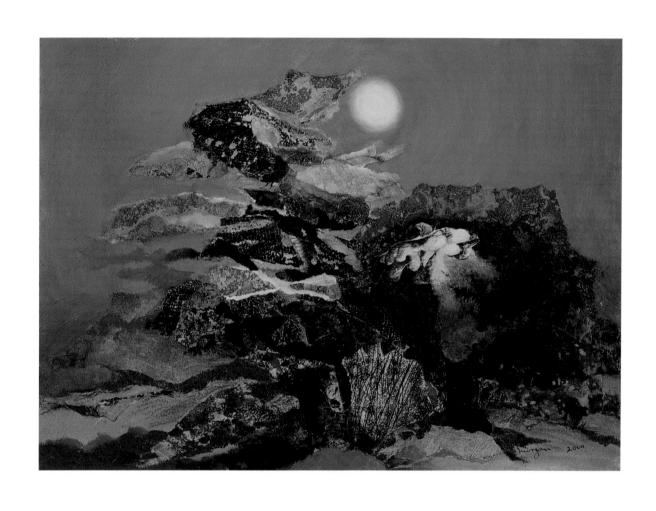

Landscape Motif I 2000 board 11 x 15

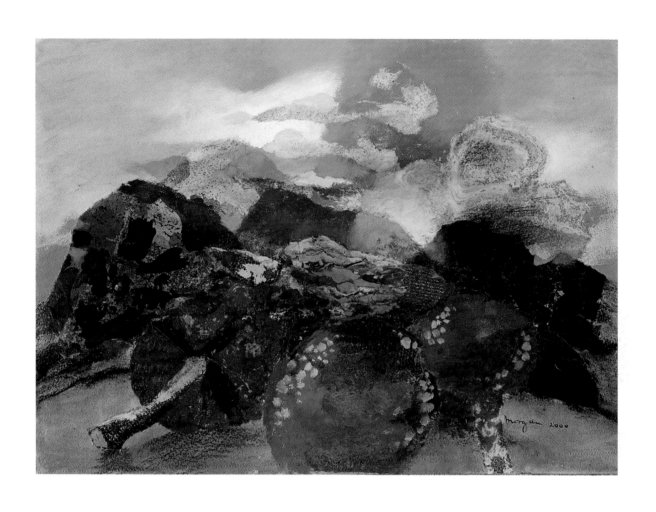

Landscape Motif II 2000 board 11 x 15

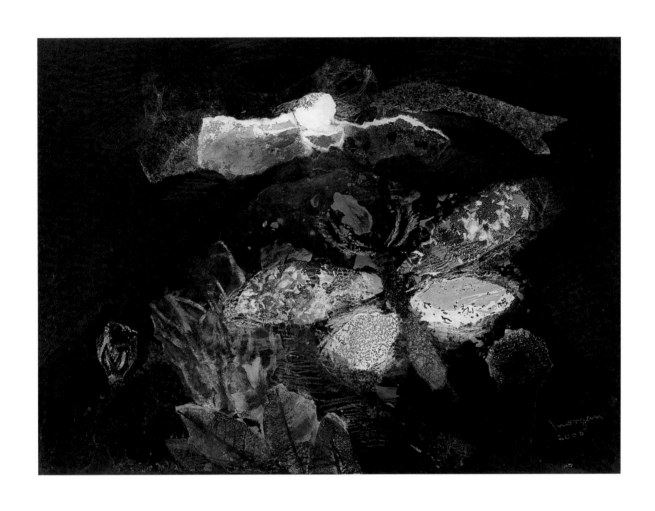

Landscape Motif III 2000 board 11 x 15

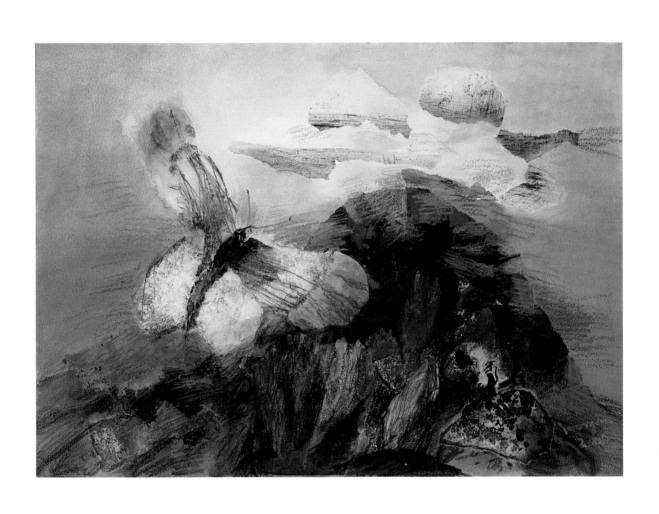

Landscape Motif IV 2000 board 11 x 15

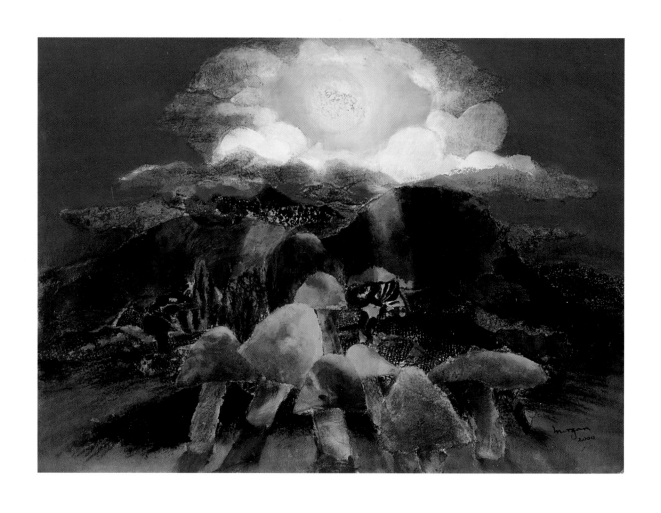

Landscape Motif V 2000 board 11 x 15

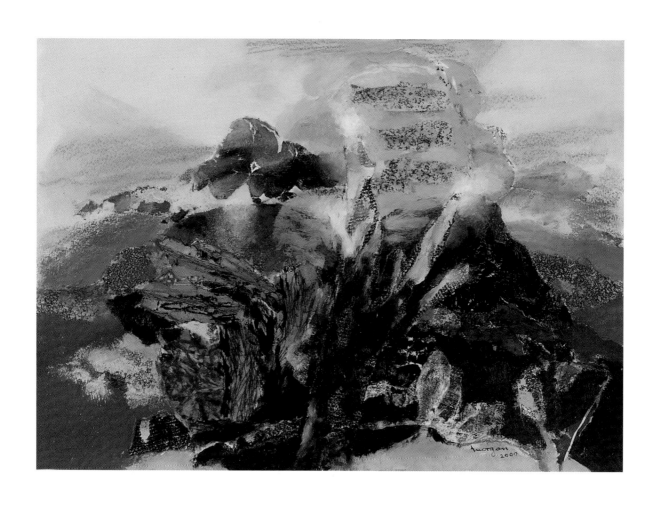

Landscape Motif VI 2000 board 11 x 15

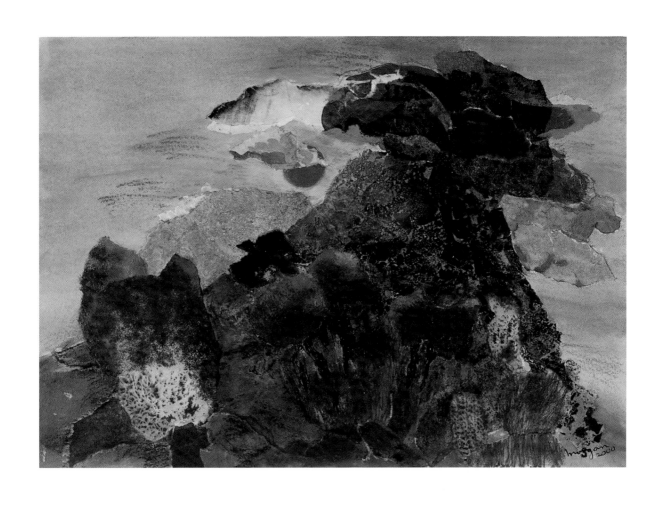

Landscape Motif VII 2000 board 11 x 15

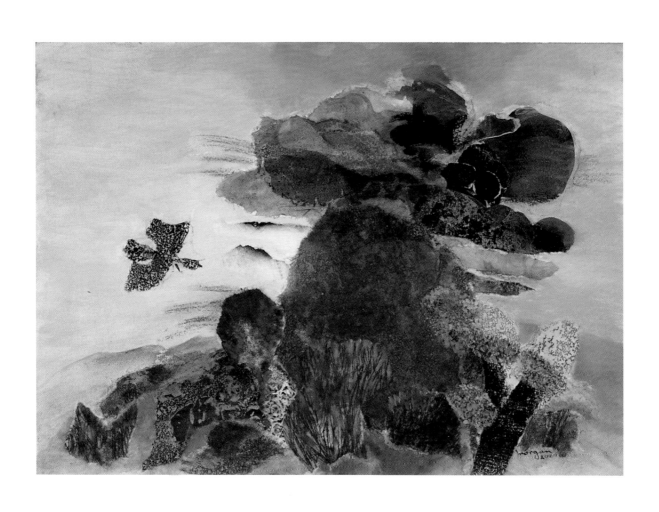

Landscape Motif VIII 2000 board 11 x 15

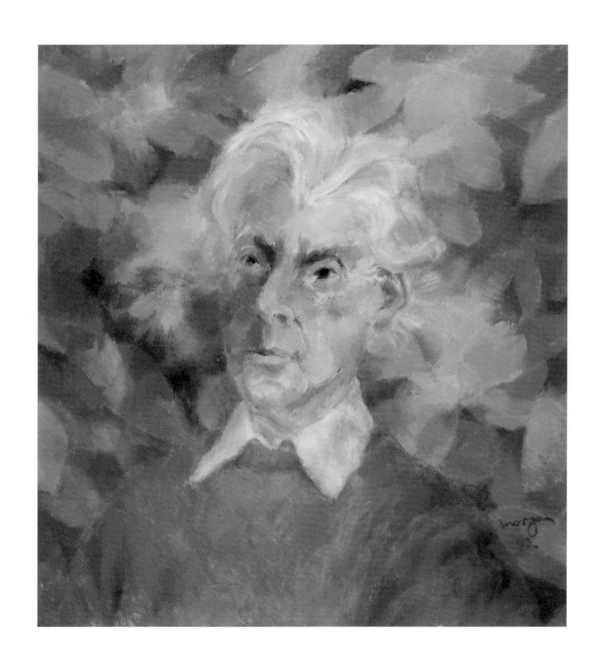

Portrait of Ronald Blythe 2002 30 x 28
[Collection: University of Essex]

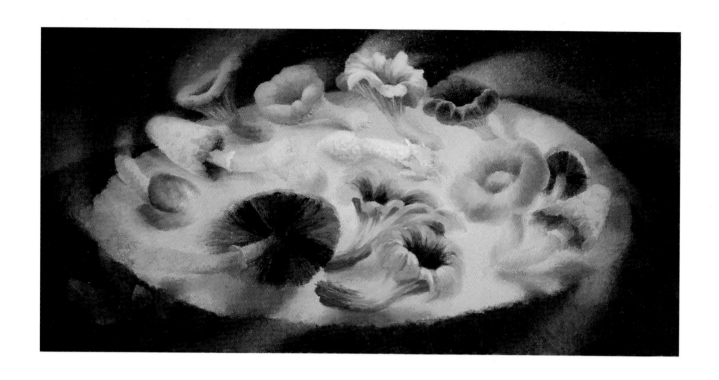

The Dance 2002 24 × 48

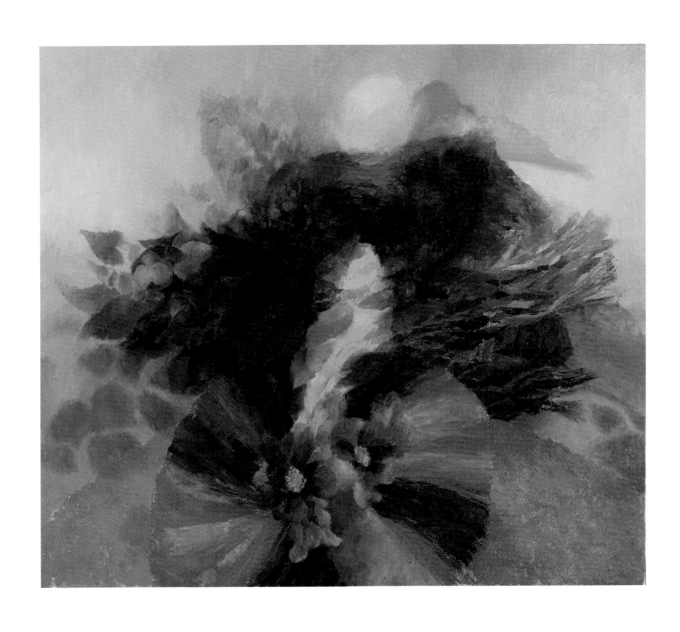

Song of the Earth III 2003 40 x 46

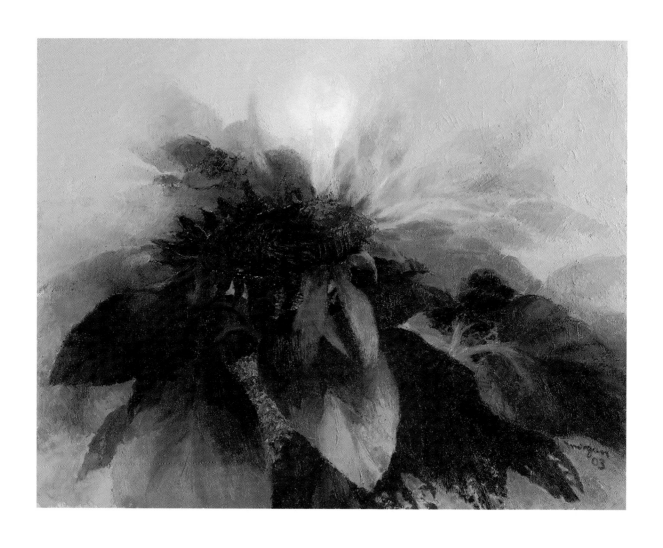

Song of the Earth V 2003 28 x 36

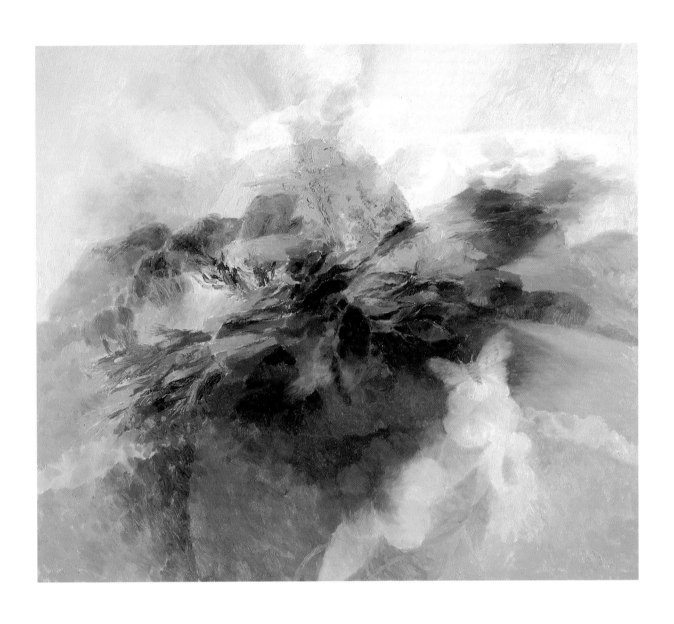

Song of the Earth VI 2003 40 × 46

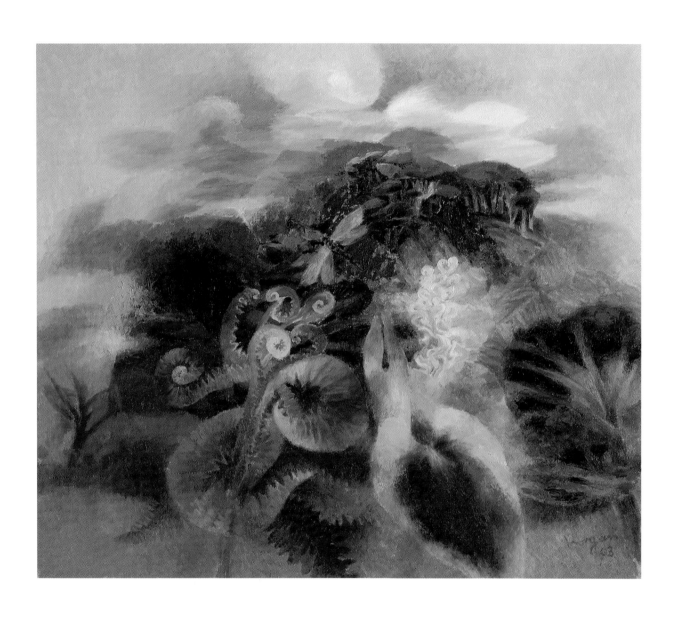

Song of the Earth VIII 2003 40 × 46

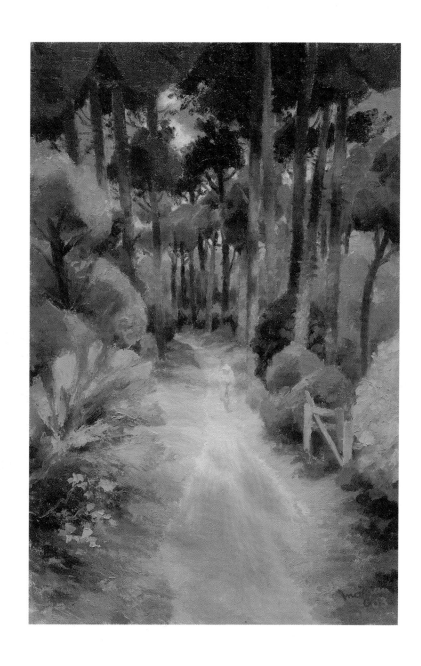

Cycle Path in Aquitaine 2003 30 x 20

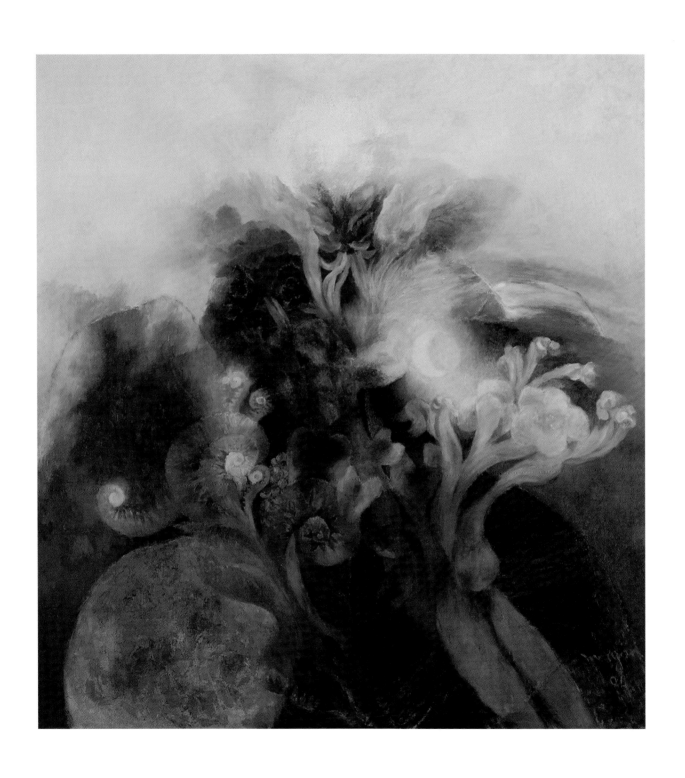

Song of the Earth X 2003 65 × 60

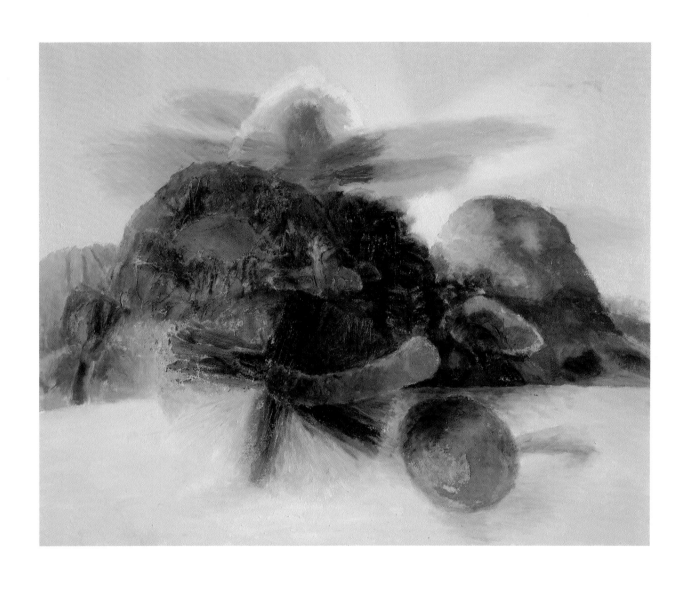

Landscape with Fungus 2004 24 x 30

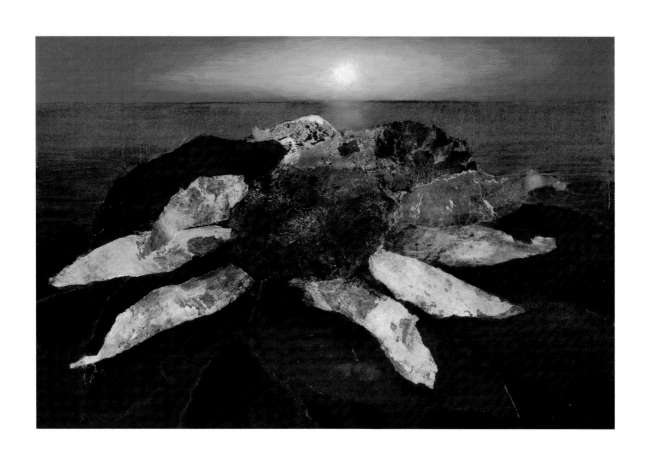

Landscape Motif I 2004 oil and collage 9 x 14

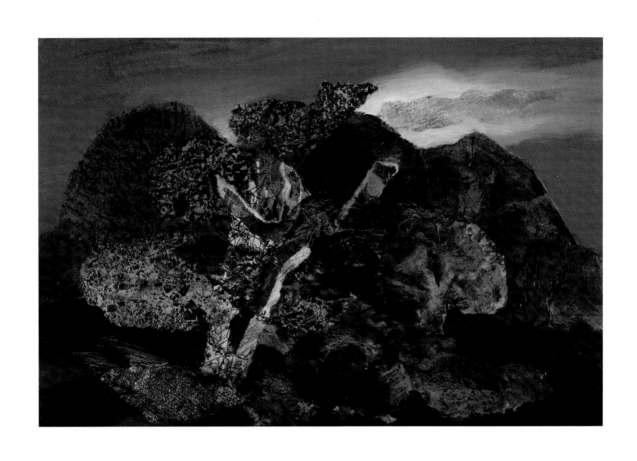

Landscape Motif II 2004 oil and collage 9 x 14

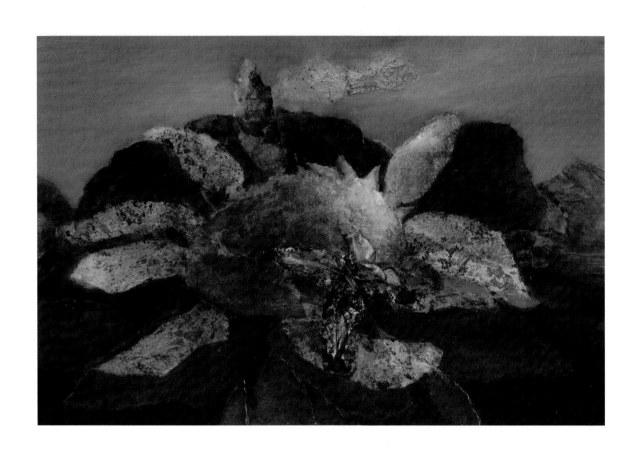

Landscape Motif III 2004 oil and collage 9 x 14

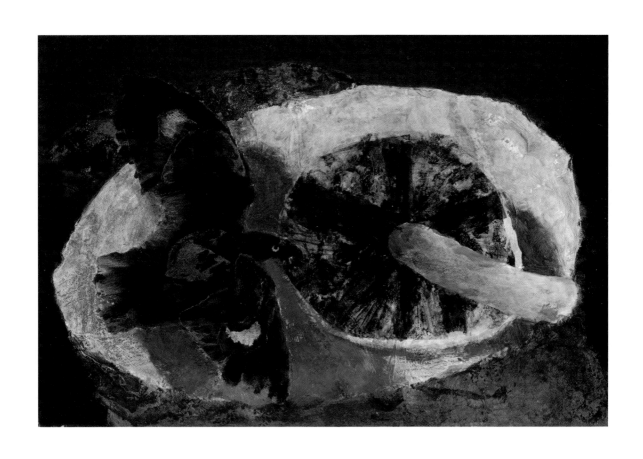

Landscape Motif IV 2004 oil and collage 9 × 14

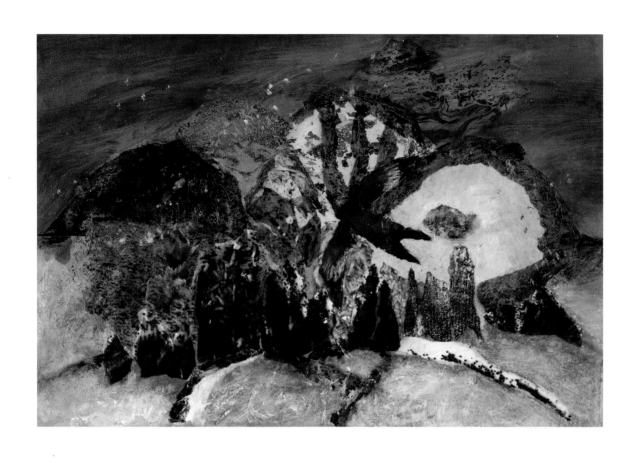

Landscape Motif V 2004 oil and collage 9 x 14

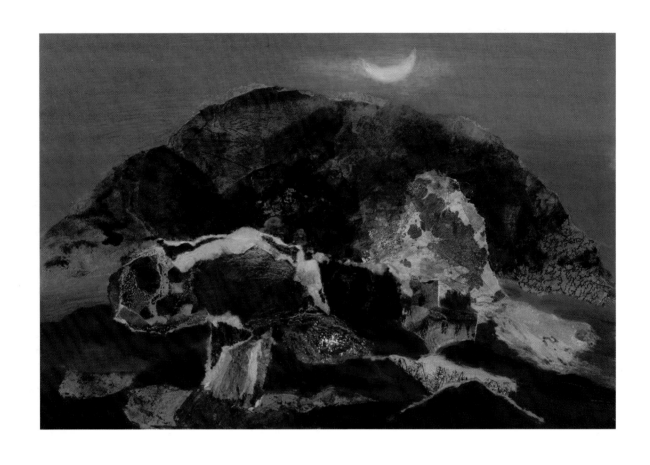

Landscape Motif VI 2004 oil and collage 9 x 14

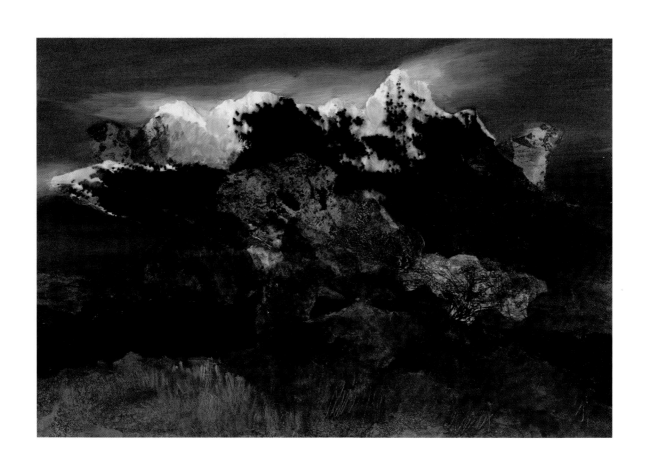

Landscape Motif VII 2004 oil and collage 9 x 14

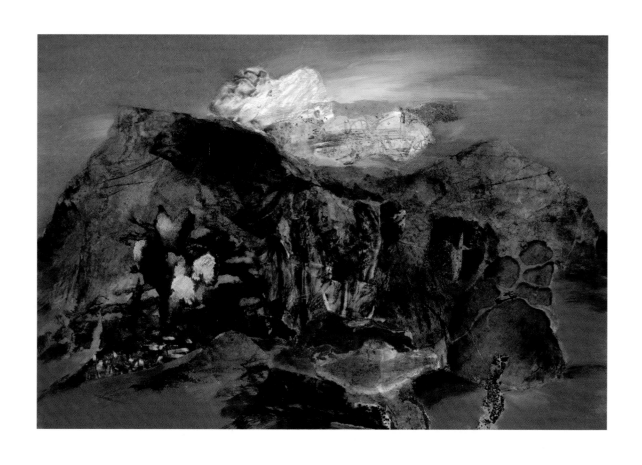

Landscape Motif VIII 2004 oil and collage 9 x 14

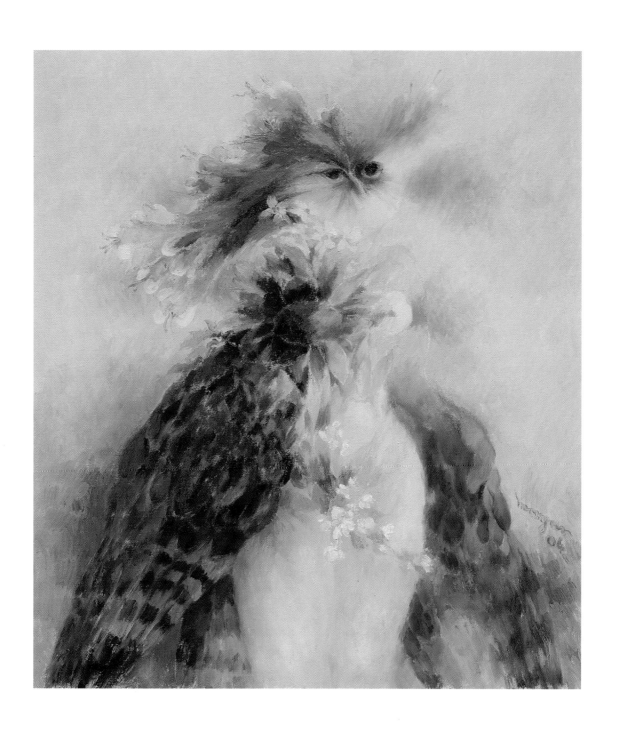

Blodeuwedd I 2004 36 x 32

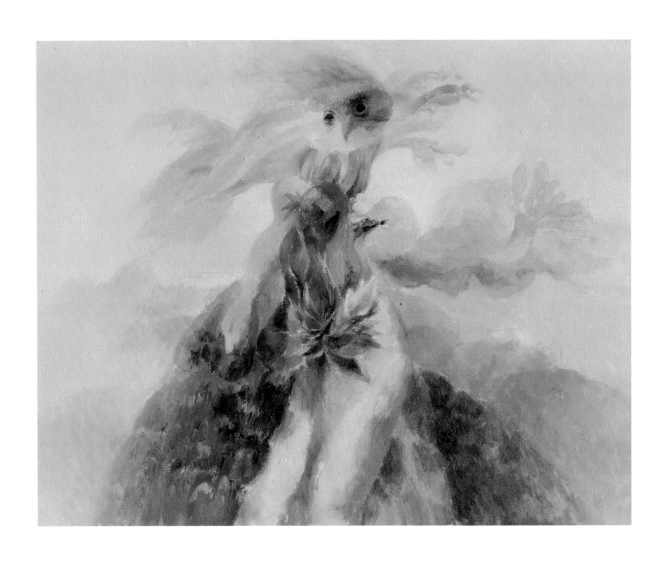

Blodeuwedd II 2005 24 × 30

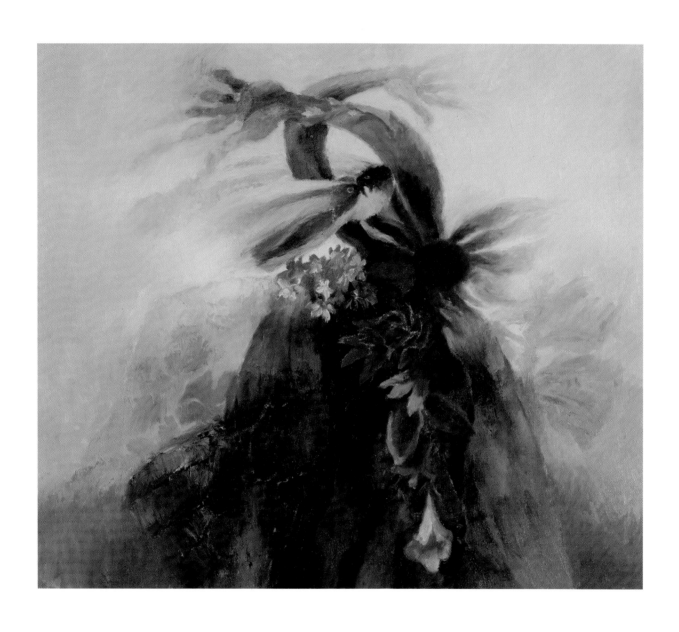

Blodeuwedd III 2005 32 × 36

watercolour
and
mixed media

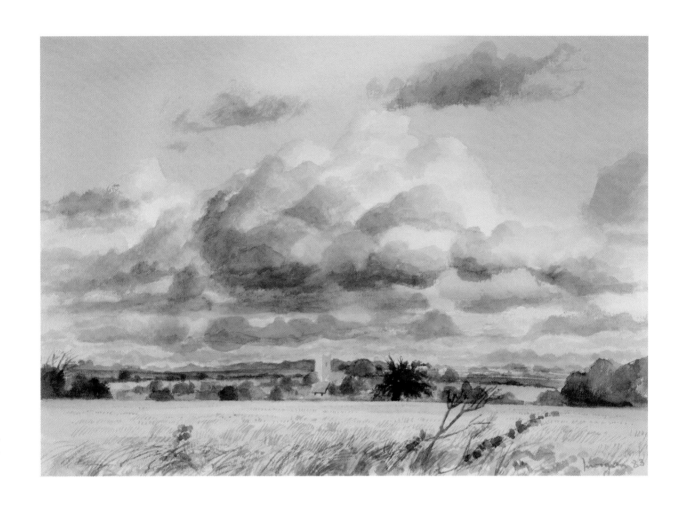

Brent Eleigh Church, Suffolk 1983 w/c 11 x 16

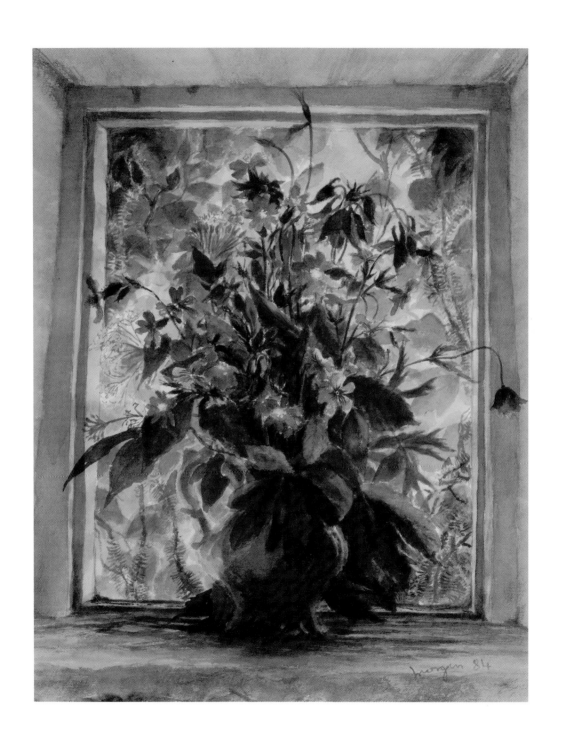

Window at Bottengoms 1984 w/c 17 x 13

Mountain Stream, Brivezac c1985 w/c 13 x 9 ½

Shells on a Dish 1997 w/c 7 x 13

Poppies 2000 w/c 13 x 9 1/2

Cedric Morris Irises 2003 w/c 21 x 14

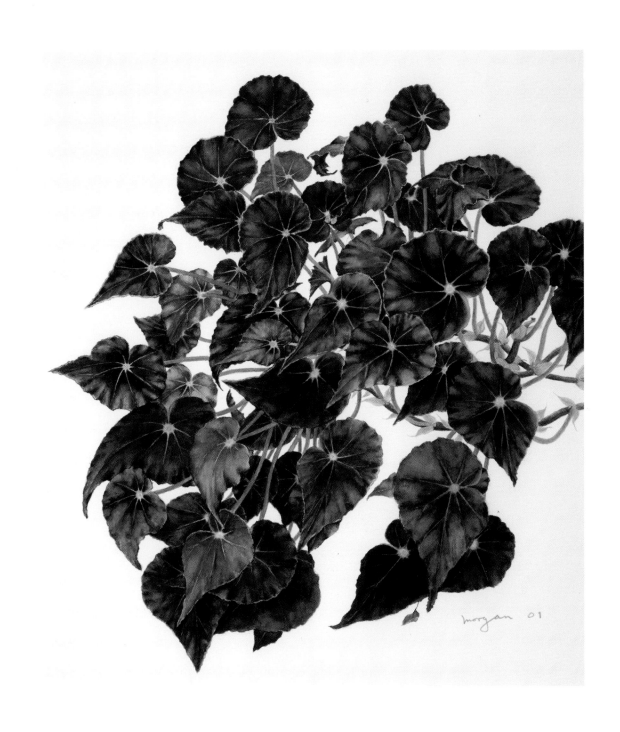

Begonia 2001 w/c 17 x 14¹/₂

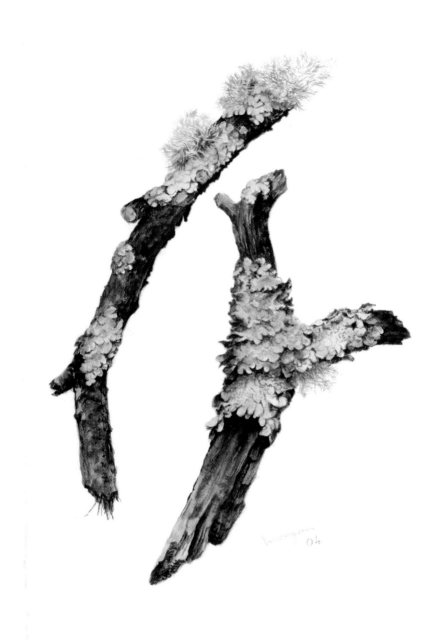

Lichen 2004 w/c 11 x 8

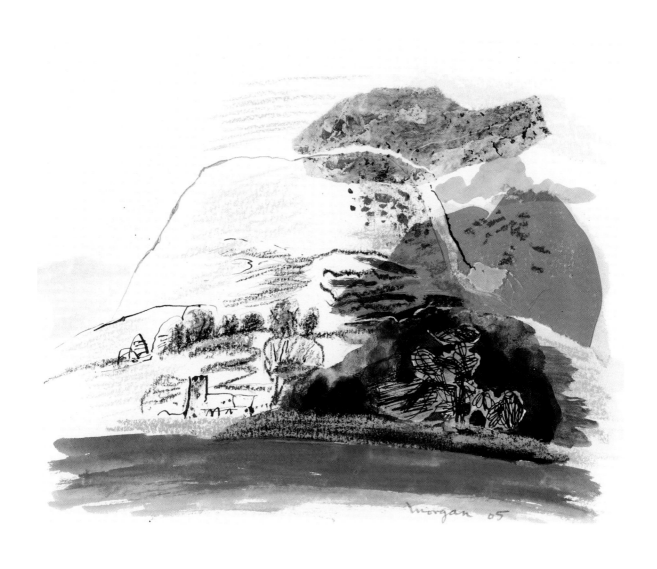

Landscape Motif I 2005 collage, w/c and pastel 8 x 9

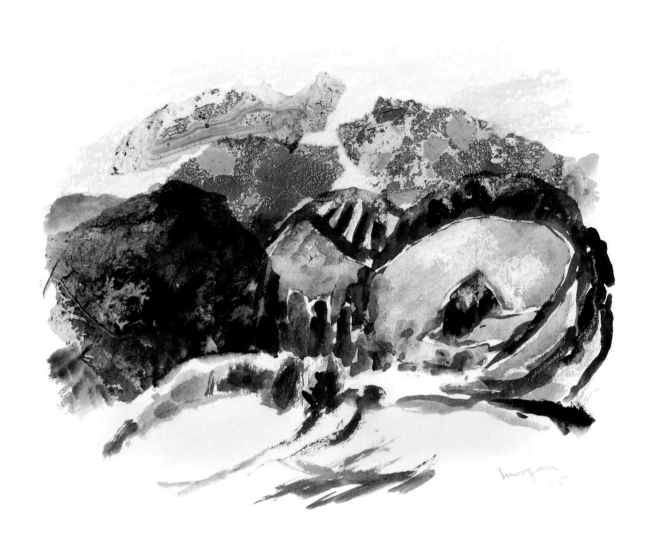

Landscape Motif II 2005 collage, w/c and pastel 8 x 9

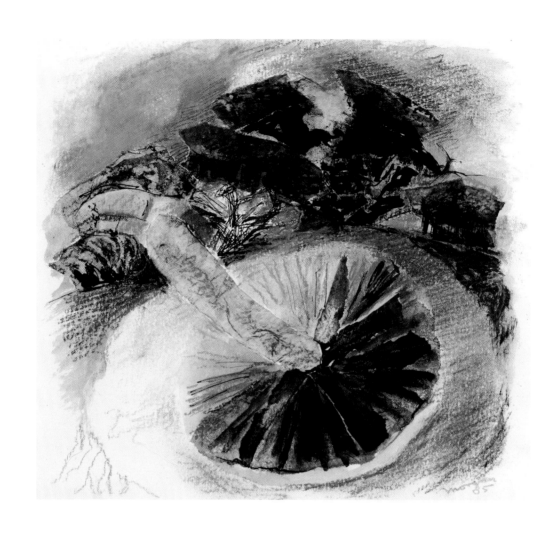

Landscape Motif III 2005 collage, w/c and pastel 8 x 9

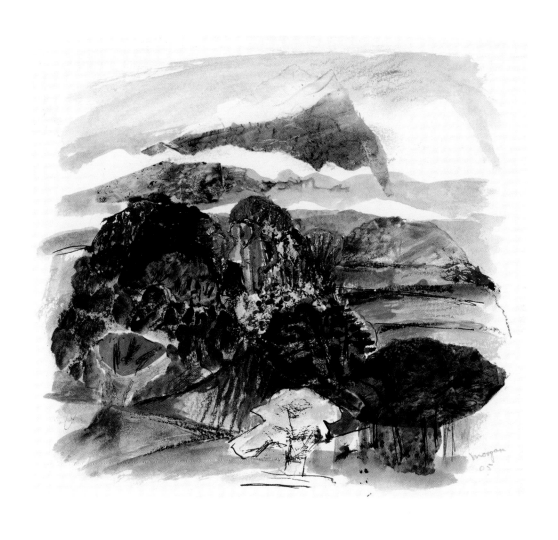

Landscape Motif IV 2005 collage, w/c and pastel 8 x 9

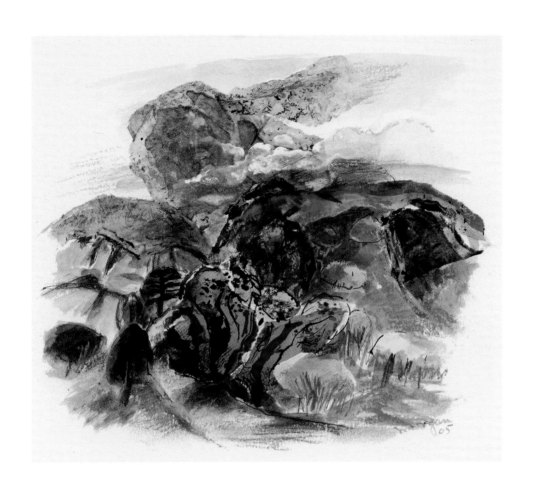

Landscape Motif V 2005 collage, w/c and pastel 8 x 9

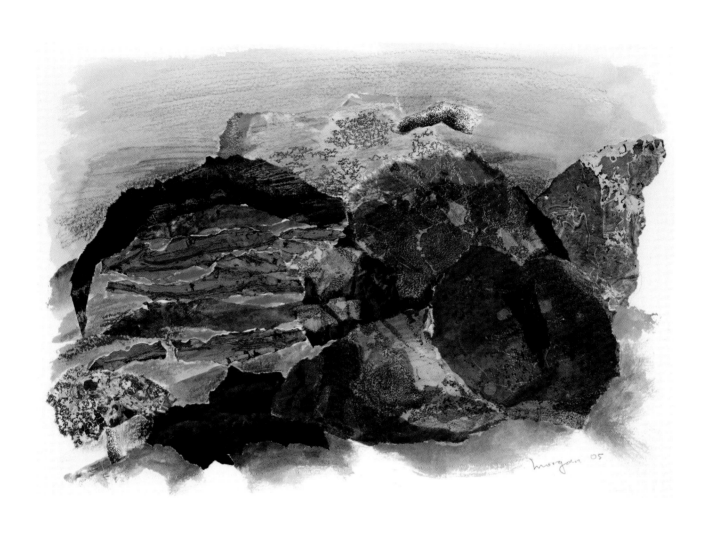

Landscape Motif VI 2005 collage, w/c and pastel 9 x 13$\frac{1}{2}$

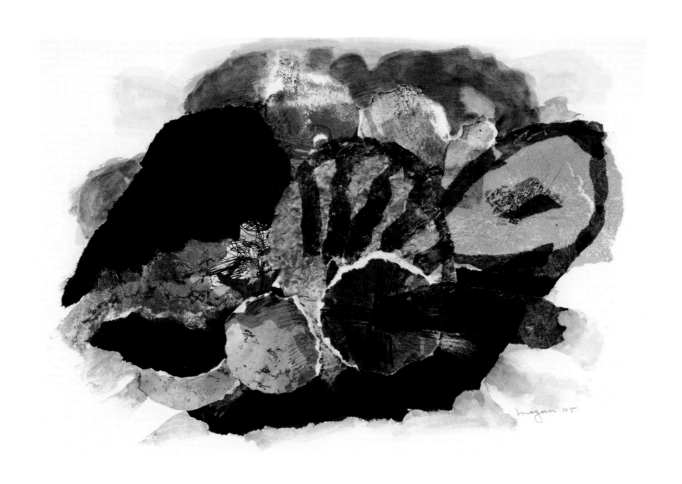

Landscape Motif I 2005 collage and mixed media 10 x 14

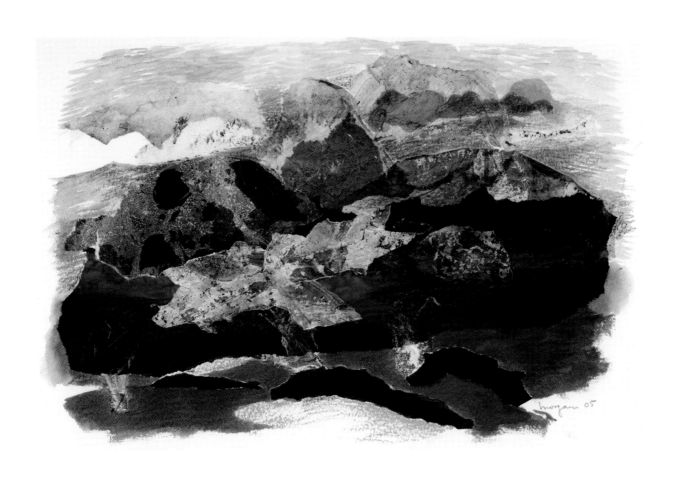

Landscape Motif II 2005 collage and mixed media 10 x 14

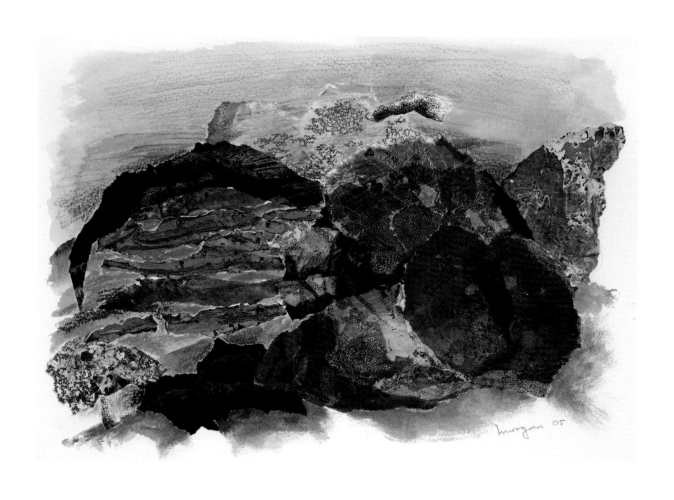

Landscape Motif III 2005 collage and mixed media 10 x 14

collage

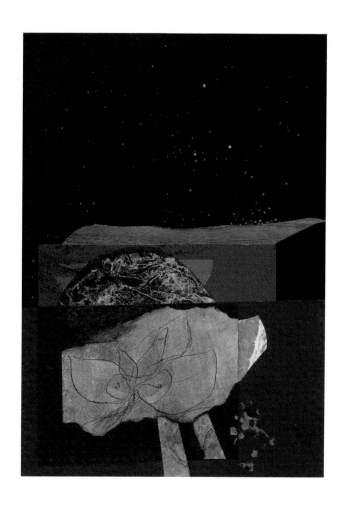

Offering for the Birth of Stars 1971 9 x 6

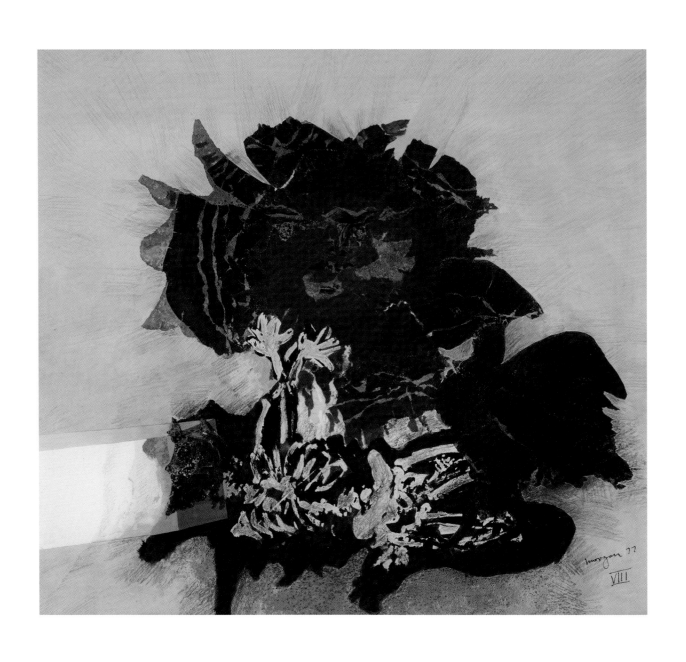

The Flaying of Marsyas VIII 1977 18 × 20

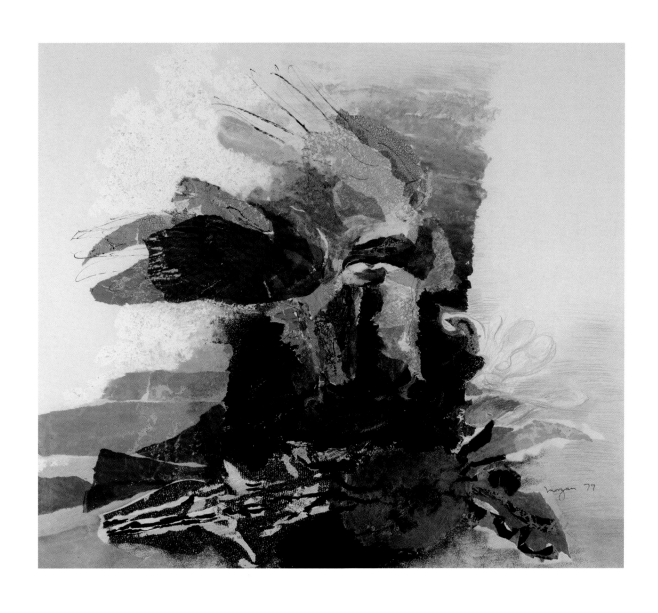

Fantasy after Mahler 1979 19 x 22

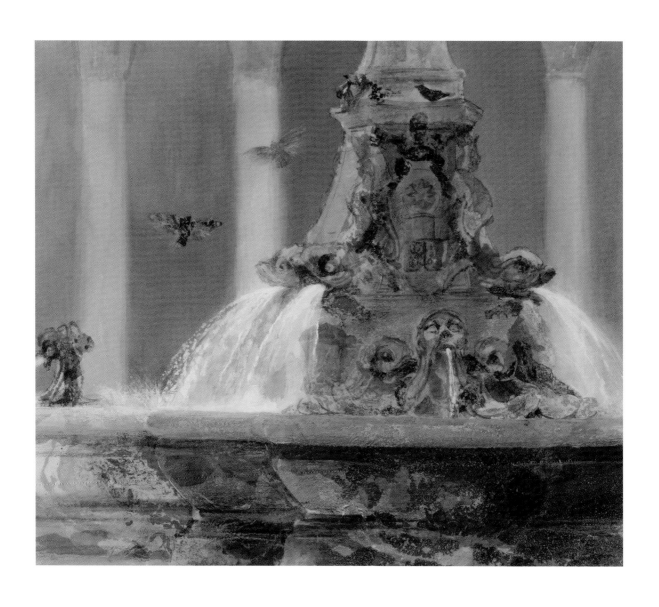

The Pantheon Fountain, Rome 1982 19 x 22

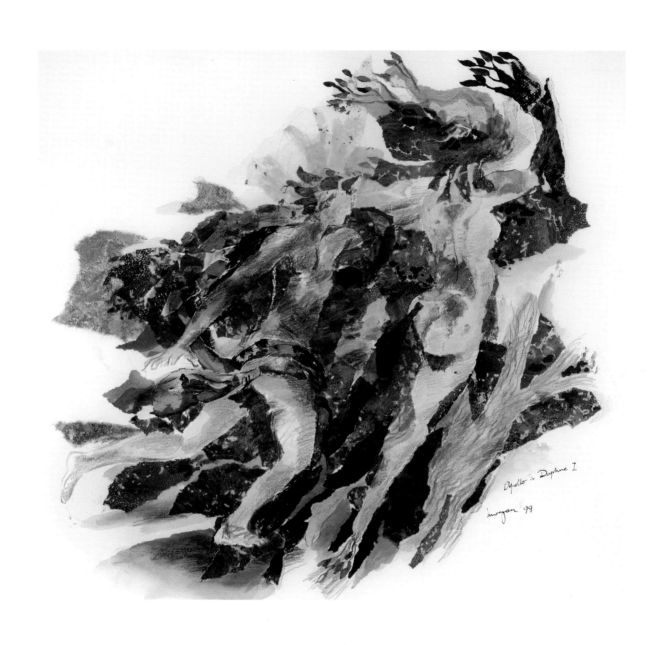

Apollo and Daphne I (after Bernini) 1999 19 x 21

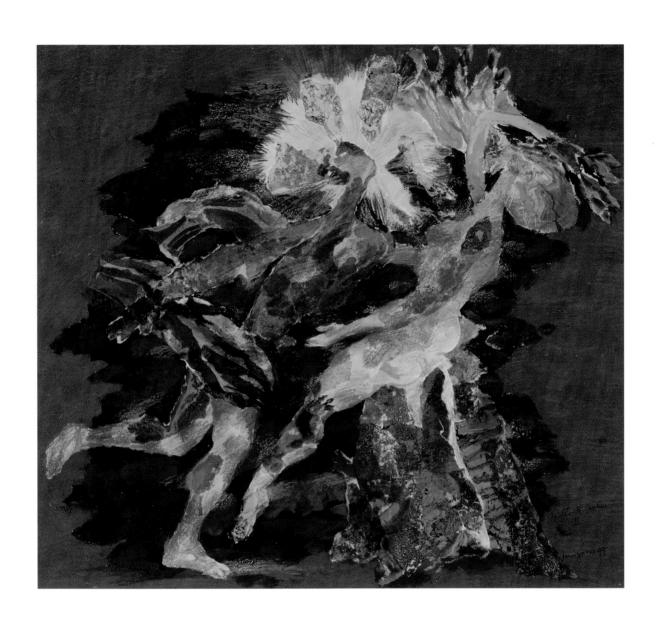

Apollo and Daphne II (after Bernini) 1999 19 x 21

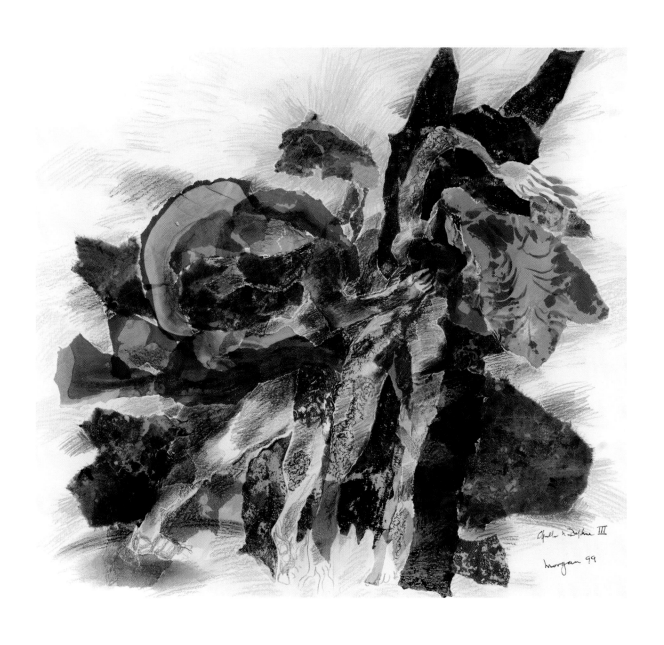

Apollo and Daphne III (after Bernini) 1999 19 x 21

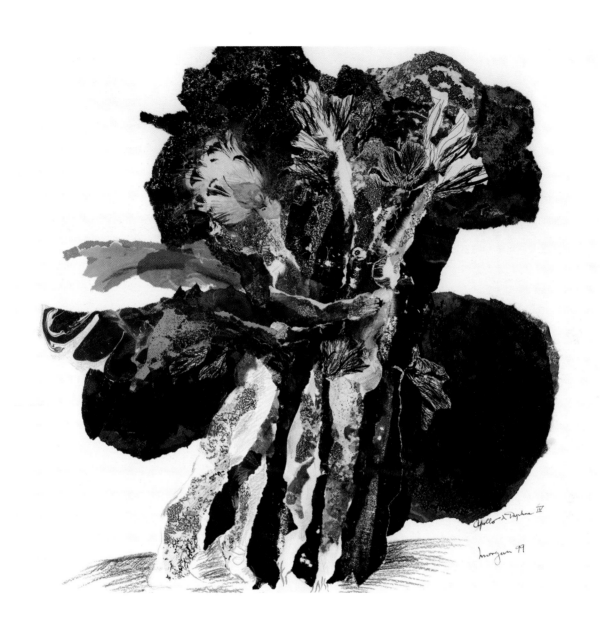

Apollo and Daphne IV (after Bernini) 1999 19 x 21

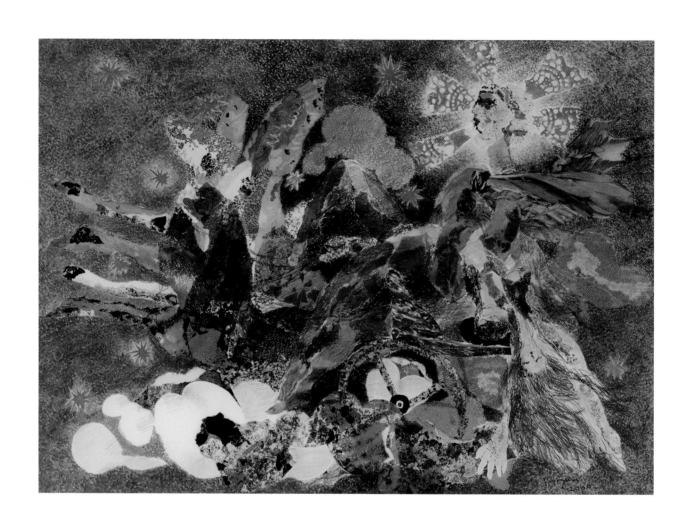

Apollo abducting Kyrene 2000 18 x 25

drawings

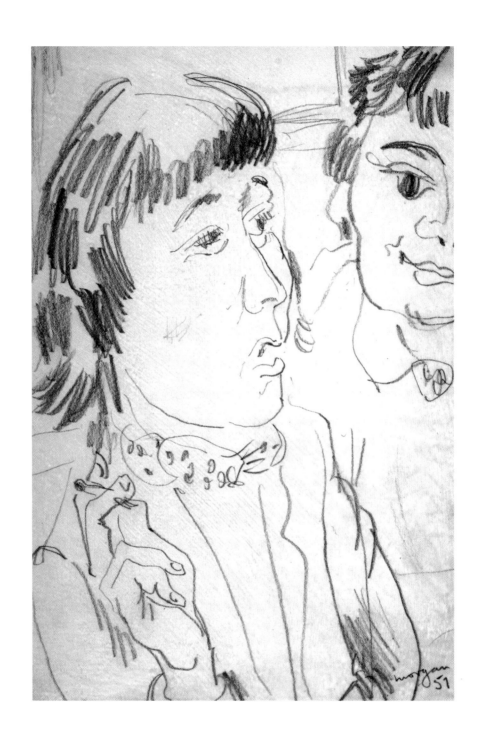

Carole and Jane 1951 pencil 9 x 6

Mandrill c1956 pencil 7 × 6

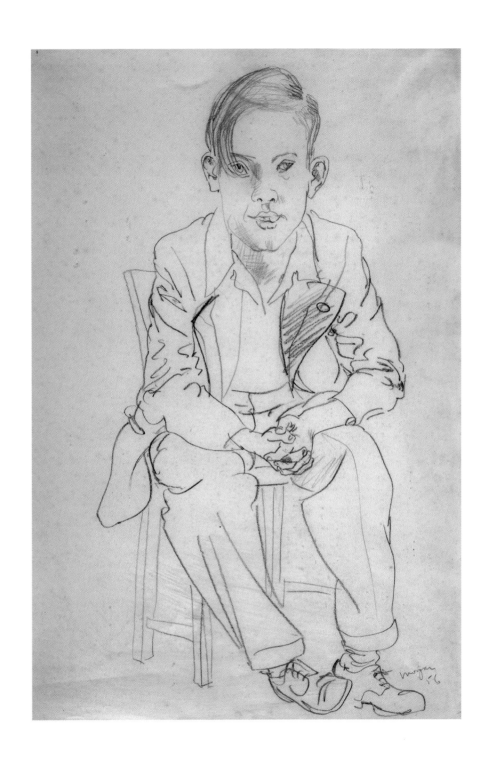

Schoolboy 1956 pencil 21 x 13

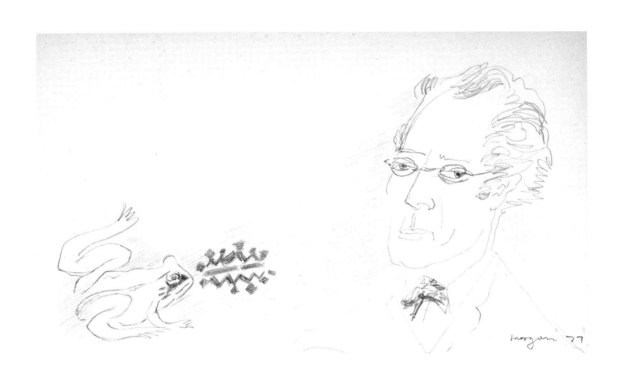

Gustav Mahler Communing with Nature 1977 pencil 4$^{1}/_{2}$ x 8

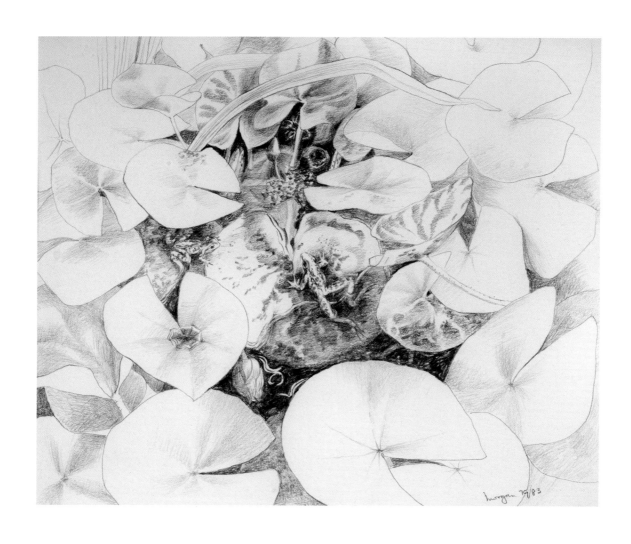

Lily Pond with Frogs 1979/83 pencil 9 x 11

Nude 1982 pencil 11 x 7

Paul 1982 pencil 9 x 7

Suzanne 1982 pencil 9 x 7

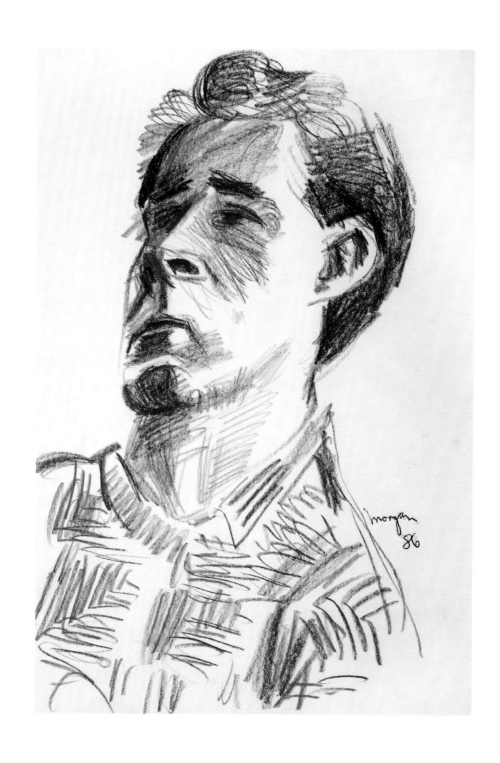

David 1986 crayon 11¹/₂ x 7¹/₂

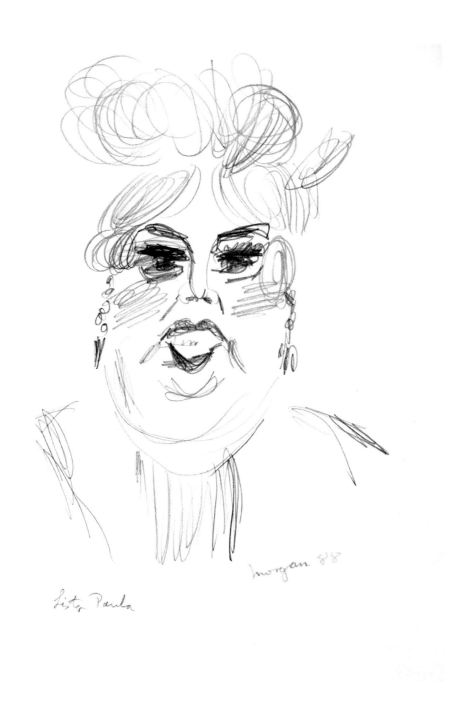

Sister Paula

morgan 88

Sister Paula the Evangelist 1988 pencil 9$^{1}/_{2}$ x 6$^{1}/_{2}$

List of Illustrations

Dimensions in inches, height before width.
AC = Artist's collection
PC = Private collection

		Oils			**page**	
1.	1946	Magnolias	canvas	28 x 36	13	AC
2.	1946	Porth, Rhondda	canvas	30 x 40	14	National Museum of Wales
3.	n/k	Portrait of the Artist's Mother	n/k	n/k	14	n/k
4.	1948	Harbour at Paimpol, Brittany	canvas	24 x 30	19	PC
5.	1948	Nude (Hetty)	canvas	36 x 24	20	AC
6.	1949	Boy Dressing	canvas	28 x 15	21	AC
7.	1950	Berw Pool, Pontypridd	canvas	28 x 36	72	AC
8.	1951	Paris, the Seine	canvas	28 x 36	73	AC
9.	c1954	Self-Portrait	board	21 x 17	23	AC
10.	1955	Portrait of Jean	board	20 x 16	23	AC
11.	1955	Mrs Tana Sayers	board	23 x 18	22	AC
12.	1955	The Chain Works, Pontypridd	board	29 x 39	24	AC
13.	1956	Priestess	board	25 x 19$^{1/2}$	22	PC
14.	c1957	Cedric Morris in his Garden	board	c20 x 25	74	Ipswich Borough Art Gallery & Museums
15.	1960	Benton End Garden	board	24 x 12	25	AC
16.	1962	Still Life with Snail Shells	canvas	14 x 18	26	AC
17.	1968	Aphrodite Resting on the Shore	canvas	20 x 30	28	AC
18.	1971	The Table of Minos VI	canvas	20 x 20	29	AC
19.	1975	Poem in Memory of Orpheus	canvas	36 x 32	30	AC
20.	1975	Lily Pond with Frogs	canvas	40 x 50	33	PC
21.	1977	Frog and Fly	canvas	10 x 13	34	PC
22.	1978	Owl over a Lily Pond	canvas	45 x 50	75	AC
23.	1979	Fantasy after Mahler	canvas	32 x 36	38	AC
24.	1979	Maenads and Satyrs in the Forest	canvas	32 x 36	76	AC
25.	1980	Dionysos at Sea	canvas	50 x 50	36	PC
26.	1981	Limpets and Ripples	canvas	36 x 32	39	AC

					page	
27.	1982/83	Leto Cursing the Lycians	canvas	36 x 32	37	AC
28.	1984	Maenad and Owl in the Forest	canvas	36 x 36	77	AC
29.	1984	Liszt and Countess Olga von Meyendorff at the Villa d'Este	canvas	36 x 32	40	AC
30.	1988	Brian Collie, David Thomas, Siegfried, Semele and Mrs Fricka-Wotan	canvas	40 x 36	46	PC
31.	1995	Blodeuwedd and the Green Man	canvas	32 x 36	52	AC
32.	1995	The Green Man in a Wood – Winter Sunrise	canvas	20 x 30	53	AC
33.	1996	The Green Man at Seed-time	canvas	32 x 36	78	PC
34.	1997	Landscape with Setting Sun	canvas	24 x 48	79	PC
35.	1997	Autumn Wood, Suffolk	canvas	24 x 30	80	AC
36.	1999	Spring Symphony	canvas	24 x 32	58	AC
37.	1999	Midsummer's Eve	canvas	32 x 36	81	AC
38.	1999	Landscape with Honeysuckle	canvas	20 x 30	59	PC
39.	1999	The Barrow of the Green Man	canvas	32 x 36	54	PC
40.	2000	Landscape with Flying Birds	canvas	32 x 36	82	AC
41.	2000	Owls under the Moon	canvas	30 x 30	83	PC
42.	2000	Landscape Motifs I-VIII	board	11 x 15	84-91	PC(I,II,V,VI)
43.	2001	Landscape with Fungus	canvas	20 x 30	64	AC
44.	2001	Winter Wood	canvas	20 x 30	64	AC
45.	2001	The Destroying Angels I	canvas	20 x 30	67	AC
46.	2001	The Destroying Angels II	canvas	22 x 36	67	AC
47.	2001	Landscape with Sunflowers	canvas	40 x 50	65	AC
48.	2002	Portrait of Ronald Blythe	canvas	30 x 28	92	University of Essex
49.	2002	The Valley of Owl Spirits	canvas	30 x 30	68	PC
50.	2002	The Dance	canvas	24 x 48	93	PC
51.	2002	Song of the Earth II	canvas	36 x 48	60	AC
52.	2003	Song of the Earth III	canvas	40 x 46	94	AC
53.	2003	Song of the Earth V	canvas	28 x 36	95	AC
54.	2003	Song of the Earth VI	canvas	40 x 46	96	AC

					page	
55.	2003	Song of the Earth VIII	canvas	40 x 46	97	PC
56.	2003	The Flight of the Sunflowers	canvas	28 x 36	66	AC
57.	2003	Cycle Path in Aquitaine	canvas	30 x 20	98	PC
58.	2004	The Song of the Earth X	canvas	65 x 60	99	AC
59.	2004	Landscape with Fungus	canvas	24 x 30	100	AC
60.	2004	Landscape with Kites, Ceredigion	canvas	30 x 40	69	AC
61.	2004	Landscape Motifs I-VIII	board oil and collage	9 x 14	101-108	AC (III PC)
62.	2004	Blodeuwedd I	canvas	36 x 32	109	AC
63.	2005	Blodeuwedd II	canvas	24 x 30	110	AC
64.	2005	Blodeuwedd III	canvas	32 x 36	111	AC
65.	2005	Blodeuwedd IV	canvas	40 x 45	57	AC

Watercolour and Mixed Media

66.	1983	Brent Eleigh Church, Suffolk	w/c	11 x 16	114	AC
67.	1984	Window at Bottengoms	w/c	17 x 13	115	AC
68.	1984	Leningrad with the cruiser Aurora	w/c	10 x 27	43	AC
69.	c1984	Venice	w/c	8 x 12	44	AC
70.	c1985	Mountain Stream, Brivezac	w/c	13 x 9½	116	AC
71.	c1985	The Dordogne at Argentat	w/c	8 x 13	42	AC
72.	c1988	Mount Etna	w/c	8 x 12	44	AC
73.	c1988	Swimming Pool, Taormina	w/c	8 x 12	45	AC
74.	c1989	Afternoon Sun, Corsica	w/c	8 x 10	45	AC
75.	1997	Morning Glory	w/c	n/k	48	PC
76.	1997	Shells on a Dish	w/c	7 x 13	117	AC
77.	2000	Poppies	w/c	13 x 9½	118	AC
78.	2003	Cedric Morris Irises	w/c	21 x 14	119	PC
79.	2001	Begonia	w/c	17 x 14½	120	AC
80.	2004	Lichen	w/c	11 x 8	121	AC
81.	2005	Landscape Motifs I-VI collage, w/c & pastel (VI dimensions: 9 x 13½)		8 x 9	122-127	AC
82.	2005	Landscape Motifs I-III collage, w/c & pastel		10 x 14	128-130	AC

Chronology

1926	Born Pontypridd, Wales
1942-4	Art School, Cardiff
1947-8	Art School, Camberwell
1951	Working in Paris
1955	Hotel mural commission, Cheltenham
1968	Goldsmiths' Company Fellowship to work and study in Crete
1972	Lectured during summer at Aegina Art Centre, Greece
1985	Organised and presented 'The Benton End Circle' exhibition of more than 40 years' work by students of Cedric Morris and Arthur Lett-Haines, Bury St Edmunds Art Gallery
1988	Classical landscape commission
1988-98	Member of the Society of Botanical Artists

Exhibitions

One-man Exhibitions since 1969

1969 Drian Galleries, London

1971 The Minories, Colchester

1973 Richard Demarco Gallery, Edinburgh

1974 Gardner Arts Centre, University of Sussex

1978 Gilbert-Parr Gallery, London

1980 Gilbert-Parr Gallery, London

1981 Retrospective – The Minories, Colchester

1982 Alwin Gallery, London

1983 Alwin Gallery, London

1985 Archway Gallery, Houston, Texas

1986 Retrospective –Taliesin Arts Centre, University of Swansea

1990 Quay Gallery, Sudbury, Suffolk

1991 Portraits of Gaia and Other Paintings, Chappel Galleries, Essex

1995 Glyn Morgan: A Fifty Year Retrospective, Simon Carter Gallery, Woodbridge

1996 The Green Man, 70th birthday celebration, Chappel Galleries, Essex

1996 Glyn Morgan – 50 Years, Oriel Llundain, London

1997 Glyn Morgan – 50 Years, Rhondda Heritage Park

1997 Retrospective, Y Tabernacl (Museum of Modern Art, Wales)

1998 Chappel Galleries, Essex

1998 Brecknock Museum & Art Gallery, Brecon

1998 John Russell Gallery, Ipswich

2001 A Vision of Landscape: The Art of Glyn Morgan, Chappel Galleries, Essex

2004 Martin Tinney Gallery, Cardiff

2004 The Song of the Earth, Chappel Galleries, Essex

2006 Glyn Morgan at Eighty, National Library of Wales, Aberystwyth

2006 Glyn Morgan at Eighty, Chappel Galleries, Essex

Group Exhibitions

1952	Edinburgh Festival
1955	Contemporary Welsh Painting and Sculpture, National Museum of Wales, Cardiff
1956	Festival of Wales
1962	Leicester Galleries, London
1968	Canaletto Gallery, London
1969	Recording Wales (Welsh Arts Council)
1970	John Whibley Gallery, London
1975	Alwin Gallery, London
1976	Gilbert-Parr Gallery, London
1976	Oriel, Cardiff (Welsh Arts Council)
1978	The Oxford Gallery
1986	Invited Artists Exhibition, Oriel, Cardiff (Welsh Arts Council)
1987	Royal Academy, London
1988	Royal Academy, London
1988	Open Exhibition, Manchester Academy of Fine Art
1988	Royal Horticultural Society, London
1988	Society of Botanical Artists, London
1988	Royal Society of Marine Artists, London
1989	Society of Botanical Artists, London
1989	Four Painters and a Sculptor from Benton End, Bury St Edmunds Art Gallery
1989	Art Expo, New York
1989	Royal Horticultural Society, London
1990	The Broad Horizon, Agnews, London (National Trust)
1990	Society of Botanical Artists, London
1991	Society of Botanical Artists, London
1992	Hallam Gallery, London

1993 Woburn Festival

1994 Master & Pupil, Cedric Morris & Glyn Morgan, Chappel Galleries, Essex

1995 Welsh Contemporaries, Oriel Llundain, London

1996 Colchester Art Society – 50 years, Chappel Galleries, Essex

1997 Aldeburgh Festival

1997 Society of Botanical Artists, London